CANTERBURY
IN
50
BUILDINGS

JOHN WOODHAMS & MARGARET WOODHAMS

AMBERLEY

First published 2021

Amberley Publishing, The Hill, Stroud
Gloucestershire GL5 4EP

www.amberley-books.com

British Library Cataloguing in Publication Data.
A catalogue record for this book is available from the British Library.

ISBN 978 1 4456 9934 9 (print)
ISBN 978 1 4456 9935 6 (ebook)

Typesetting by SJmagic DESIGN SERVICES, India.
Printed in Great Britain.

Contents

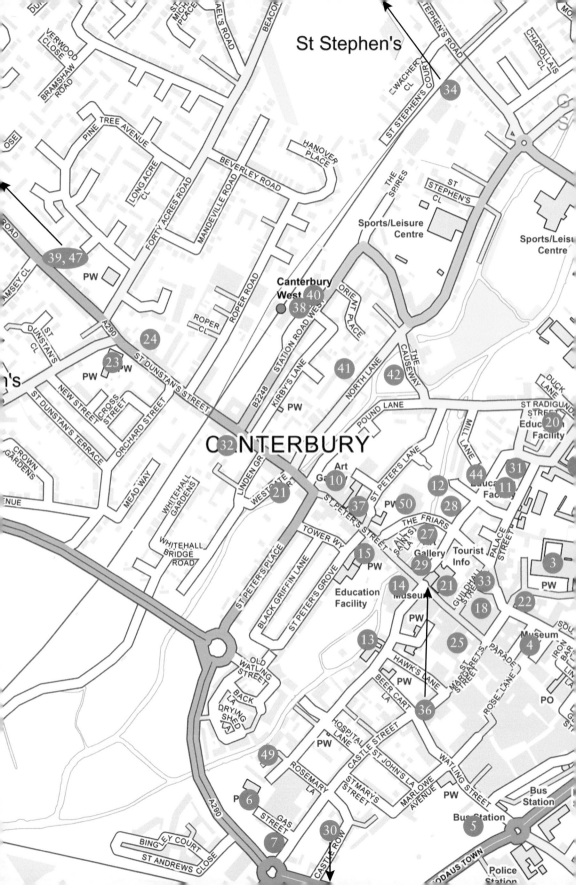

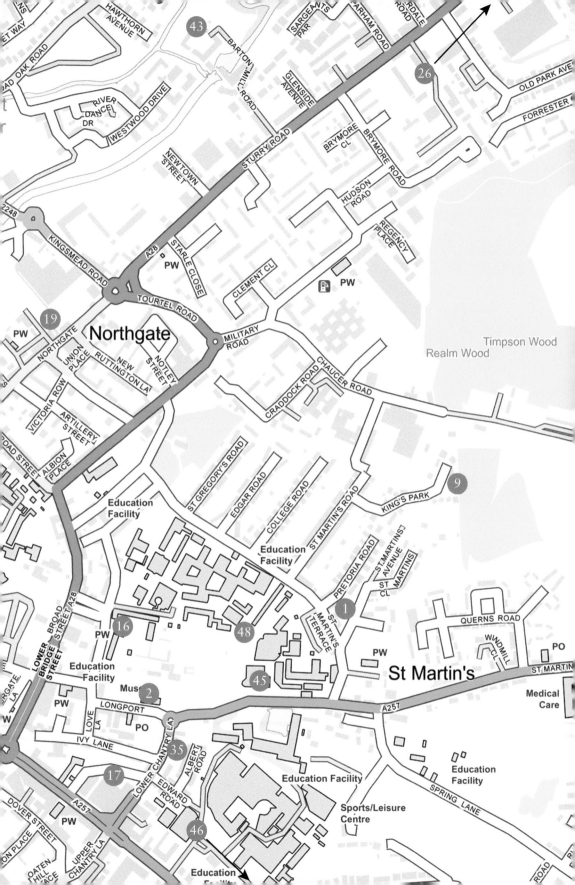

Key

Introduction

Flint tools and fragments of ancient pottery are evidence of centuries of human occupation of the area surrounding the River Stour, now known as Canterbury. By the end of the Iron Age, in the first century AD, it had become the home of a tribe known as the Cantiaci although there is no built evidence for these long years of habitation.

The history of the city as we know it, therefore, really begins with the arrival of the Romans. The invasion of AD 43 was followed by swift colonisation and by AD 70, the former Celtic settlement had been appropriated and given the name Durovernum Cantiacorum or 'fort of the Cantiaci by the alder swamp'. It was a typical Roman city, built on a grid pattern with a theatre, forum, public baths and a temple. With its proximity to the ports of Dubrae (Dover) and Rutupiae (Richborough), it was of considerable strategic significance despite never being a major military garrison.

No complete Roman buildings remain but it is possible to find traces of them within the modern city. In the late third century, a protective earth bank was built

A view of Dane John Mound taken from the city wall.

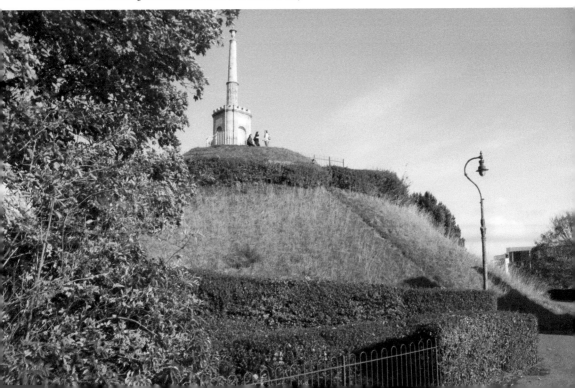

around the settlement, together with a wall containing seven gates which served as a template for the later medieval ones. Dane John Gardens, a park within the city walls, includes what was originally a Roman burial mound; a section of the Roman wall stands in St Radigund's; the foundations of a bath house can be viewed in the lower floor of 20–21 St Margaret's Street; and examples of Roman brickwork can be seen in the fabric of St Martin's Church, St Peter's Church and the Queningate.

The Romans left Britain in AD 410 and Durovernum Cantiacorum slid into a slow decline until it appears to have been largely abandoned. The departure of the Romans in Britain saw the subsequent arrival of various Germanic tribes, including Jutes, Angles and Saxons; the excavation of rare late fifth-century pottery outside of the city walls hints at some occupation of the site although how many may have lived there is impossible to know.

By the end of the sixth century, Britain had been divided into various small kingdoms, each with their own ruler. The most powerful of these rulers was King Ethelbert of Kent, who had established himself in an estate within the old Roman walls of the place he now referred to as Cantwareburh, the 'stronghold of the Kentish men'. Ethelbert had consolidated his position by the forging of careful alliances, the most important being the one made when he married Bertha, the daughter of Charibert, King of the Franks. The Frankish kingdom, in what is now France, was the most powerful state in Western Europe and Ethelbert's close ties to it did much to help Kent's influence within Britain as a whole.

Bertha was a Christian and when she moved to Canterbury, she insisted that her pagan husband provide her with an appropriate location in which to continue practising her faith. Ethelbert obliged by renovating a dilapidated Roman building just outside the city walls which may well have had connections to early Roman Christian worship. Tradition has it that Bertha would walk to services through a gate in the city wall near to what is now called the Queningate – or Queen's Gate. Building works over centuries have changed how this building would have appeared to Bertha, but 1,400 years later, St Martin's is still a working church, making it the oldest church in the English- speaking world and thus part of Canterbury's designation as a UNESCO World Heritage Site.

Canterbury's history was changed forever when, in AD 596, Pope Gregory decided, either of his own volition, or possibly at the request of Queen Bertha, to send a mission to England. The aim was not only to convert its pagan inhabitants to Christianity but to encourage those who were already Christian to follow the teachings of Rome rather than adopting those of the Celtic style of Christianity which had developed after the departure of the legions, whose adherents were stubbornly uninterested in being ruled by the Pope. Gregory sent a Benedictine prior named Augustine together with forty monks who finally arrived in the Isle of Thanet in AD 597. They made their way to Canterbury, knowing they would find a welcome with Ethelbert and Bertha. Ethelbert was willing to allow them to go about their work and St Martin's Church became the centre of their early activities of preaching and conversion. In fact, in AD 598 he granted Augustine a parcel of

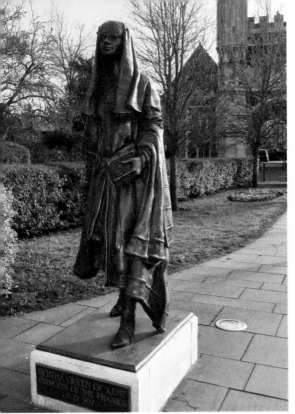 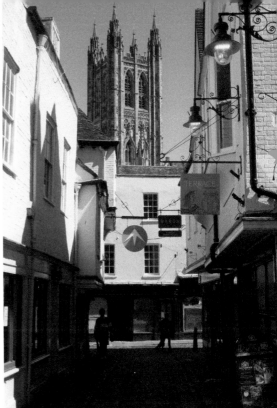

Above left: The statue of Queen Bertha at Lady Wootton's Green, with Fyndon Gate beyond.

Above right: Butchery Lane, with the cathedral's Bell Harry Tower beyond.

land outside the city walls on which to construct a monastery to house himself and his followers; this was completed in AD 613 and remained as a busy working foundation until its dissolution and destruction by Henry VIII in 1538. Today it is also part of the World Heritage designation, its ruins open to the public.

By AD 601, King Ethelbert had become a Christian and gave Augustine permission to begin work on what was to be Canterbury's first cathedral, on land within the walls and very possibly on the site of Ethelbert's own palace. Destroyed by fire in 1067, none of this building is now visible although excavations in 1993 uncovered part of the Anglo-Saxon foundations beneath the existing nave and south transept.

In 1066, the Normans had invaded Britain, and Canterbury was one of the first places William the Conqueror passed through on his triumphant journey from the scene of his victory at Hastings. Lanfranc became the first Norman Archbishop of Canterbury and understandably upset at the loss of his cathedral, he set about building a bigger and better version. Little now remains of that building apart from the crypt with its fine examples of Norman/Romanesque rounded arches and massive columns decorated with exceptional carvings of flora and fauna.

The murder of Thomas Becket within Lanfranc's cathedral in 1170, saw Canterbury become ever more prosperous as thousands of pilgrims journeyed to

the city to pray at the archbishop's shrine. In 1174, a fire in the cathedral choir led to an ambitious rebuild, which saw the first use of Gothic architecture in the country. In 1220 the newly built Trinity chapel at the cathedral's east end became Becket's resting place and by the late 1370s, Lanfranc's now crumbling nave was being replaced with the Perpendicular Gothic space we see today.

The Reformation led to Henry VIII's destruction of Becket's tomb in 1538 and the end of the city's life as a centre of Catholic pilgrimage. Christ Church Priory was dissolved and subsequently became the site of what is still the King's School. During this period of religious turmoil, Canterbury offered a sanctuary to large numbers of Protestant Huguenot refugees fleeing Catholic persecution in France and the Low Countries; they brought with them their mastery of weaving, especially fine silks, and this helped ensure Canterbury remained a prosperous place. Various timber-framed buildings in the city survive from this period of commercial success.

The Civil War between 1642 and 1651 brought troubled times to the city and to its cathedral, the latter being treated with scant respect by Cromwell's Roundheads. At one point, some 200 horses were stabled in the nave and much of the original medieval stained glass was destroyed by ardent Puritans such as the infamous Blue Dick Culver.

The eighteenth century saw Canterbury become a market town with only a few industries such as paper- and leather-making offering employment; it remained a

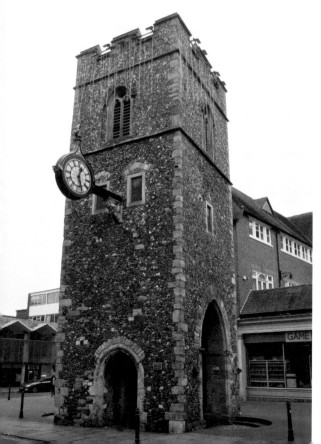

Following the air raids of 1942, the tower is all that remains of St George's Church, where Christopher Marlowe was baptised in 1564.

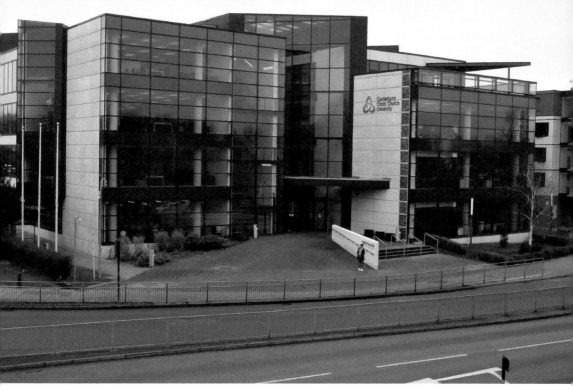

The library of Christ Church University is a modern landmark alongside the city's ring road.

relative backwater despite the coming of the railways in 1830 when the Canterbury to Whitstable line became the world's first fee-paying passenger railway.

The city suffered during the Second World War with a raid on 1 June 1942 causing the deaths of forty-eight people whilst also destroying some 800 buildings. Major rebuilding did not begin until a decade after the end of the war when the ring road was constructed outside the city walls to address increasing traffic problems which allowed for the subsequent pedestrianisation of the city centre.

In 1965, the University of Kent opened on an attractive campus at Tyler Hill overlooking the city, its architecture typical of what are often called the 'plate-glass' universities of the period. In 1962, Christ Church College was opened primarily as a teacher training college. Having gained university status in 2005 it has developed rapidly with its halls of residence and library major features on the city's busy ring road. In 2007, the arrival of HS1 cut train journey times to and from London to fifty minutes, making life in the city appealing to increasing numbers of residents and tourists; roughly 7 million of the latter visit each year, over a million of them heading to the cathedral.

In 2017, that same cathedral began a five-year restoration programme called The Canterbury Journey. Helped by a substantial grant from the National Lottery Heritage Fund, the work has included repairs to the roof, the West Towers, Christ Church Gate, the organ and stained-glass windows, as well as the construction of a new visitors' centre, leaving the cathedral a secure future in the heart of this small but flourishing city.

The 50 Buildings

The exact date of the arrival of Christianity in Britain is unknown and it is possible that some knowledge of the faith was present as early as the second century. By AD 314, the persecution of Christians was ended by Emperor Constantine and by AD 391, it had become the official religion of the Empire under Theodosius. Archaeological and written records of the late fourth century show that British Christians were well organised into distinct regions with individual bishops. There was even a Christian governor of one of the provinces.

Rome's influence over British Christians declined after the last soldiers left in AD 407, whilst invading pagan Germanic tribes pushed Christian communities ever westward towards Cornwall, Wales and eventually to Ireland. In the fifth and sixth centuries, Scotland was converted and a distinctive style of what is often called Celtic Christianity developed in these areas. By AD 596, Pope Gregory felt that something needed to be done, not only to bring these communities back under the control of Roman Christianity, but also to convert the rest of pagan England. His solution was to send a group of missionaries to Britain led by Augustine, the abbot of Gregory's former monastery in Rome.

In AD 597, Augustine and forty monks duly arrived on the shores of Kent, charged by the Pope to carry out the work necessary to make Roman Christianity the religion of Britain as a whole. Granted leave to do so by Kent's King Ethelbert and encouraged by his Christian wife, Bertha, Augustine must initially have worshipped in the old Roman building the King had restored for his wife's use at the time of their marriage. Stained-glass windows at the west end of the church show scenes from the story of Augustine, Ethelbert and Bertha and serve as a reminder of their significance in the history of Christianity. Statues of Bertha and Ethelbert were erected on Lady Wootton's Green in 2004 and 2005, on the route traditionally taken by Bertha as she walked to and from the church 1,400 years ago.

It has been suggested that the original Roman building just beyond the city walls may have been a mortuary chapel due to the number of burials found in the immediate surroundings. Traditionally, the dead were not buried within Roman city walls so this seems a plausible explanation of the building's early function.

The church is now dedicated to St Martin, Bishop of Tours in France, where Bertha once lived, and is a fascinating mixture of Roman, Saxon and medieval

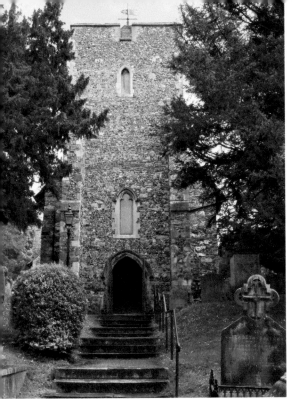

Above left: The fourteenth-century tower and main door to St Martin's Church.

Above right: Original Roman bricks have been incorporated into the Anglo-Saxon structure of the church.

Right: The east end of the building from the churchyard.

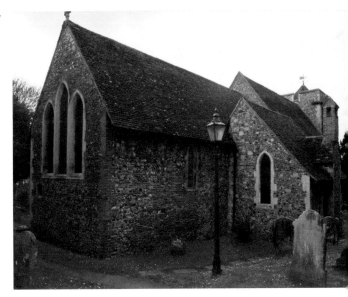

styles. There are many red Roman bricks in its construction and some sections of wall consist entirely of Roman tiles. The remains of a Roman tomb are also built into the structure. It is thought that the blocked-off door in the chancel may have been the entrance to the building in Bertha's time. The western half of the church with its Saxon windows was restored in the seventh century and the font is some 900 years old, having probably originally been in the cathedral. The tower is a

later medieval addition dating from the fourteenth century. Outside in the large and peaceful grounds are buried Sidney Cooper, a famous local artist, and Mary Tourtel, the creator of Rupert Bear.

2. St Augustine's, Longport (AD 598)

The monks who arrived with Augustine in AD 597 were in immediate need of somewhere to carry out the required daily offices of prayer. Ethelbert granted them a site outside the city walls and the abbey was founded there in AD 598, dedicated to saints Peter and Paul. The original buildings were probably wooden for quickness of construction with a stone church not being consecrated until AD 613. Archaeological discoveries have established that for several hundred years, the monastery was not much more than a collection of small buildings within a boundary wall, some made of reused Roman bricks.

In AD 670s, Archbishop Theodore of Tarsus collaborated with the abbey's Abbot Hadrian in setting up a school with a fine library attracting many scholars. The monks gained a reputation for the quality of the illuminated manuscripts they created in their own scriptorium. The remains of St Mildred were also housed at the abbey from the eighth century which helped augment its renown.

Perhaps it was this reputation that allowed the abbey to be the only one in Kent to survive Viking destruction in the late ninth century, so that when Dunstan became Archbishop in AD 959, the abbey was still flourishing if in need of a little care and attention. Having overseen its refurbishment and reorganised the abbey so that it adhered more closely to Benedictine traditions, Dunstan added St Augustine to its dedication in AD 978. It is by that saint's name it has been known ever since.

In 1011 a fresh wave of Viking incursions threatened the city. Abbot Aelfmaer seems somehow to have convinced the descriptively named Viking leaders Thorkell the Tall and Olaf the Stout to leave the abbey unharmed before sensibly fleeing himself. Archbishop Alphege was less fortunate; he was captured and refused to allow his followers to pay the 3,000 pounds of silver demanded as ransom. After a drunken evening, his captors pelted him with the ox bones left over from their evening feast before finishing him off with a sword.

The first Norman abbot, Scolland, demolished the abbey's Saxon structures and used the stone as rubble filler for the new buildings of Caen stone; none of these remain thanks to the efficiency of Henry VIII's demolition experts in the Reformation years of the 1530s and 1540s, who left only the north nave wall of a later medieval building standing. Some of the stone was sold at 8 pence a cartload so no doubt the abbey's fabric is to be found dotted around in other local buildings.

In 1539, some of the abbey buildings were converted into a royal residence for Anne of Cleves, Henry's spurned fifth wife. A timber-framed building, privy and chapel were constructed for her comfort.

In the centuries that followed, the site was owned by various local dignitaries, gradually falling into neglect until it was purchased in 1844 and became

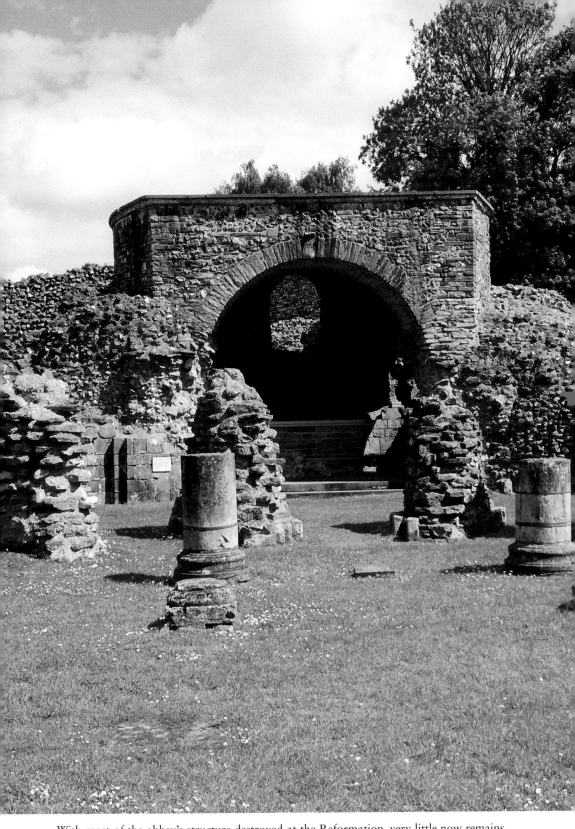

With most of the abbey's structure destroyed at the Reformation, very little now remains.

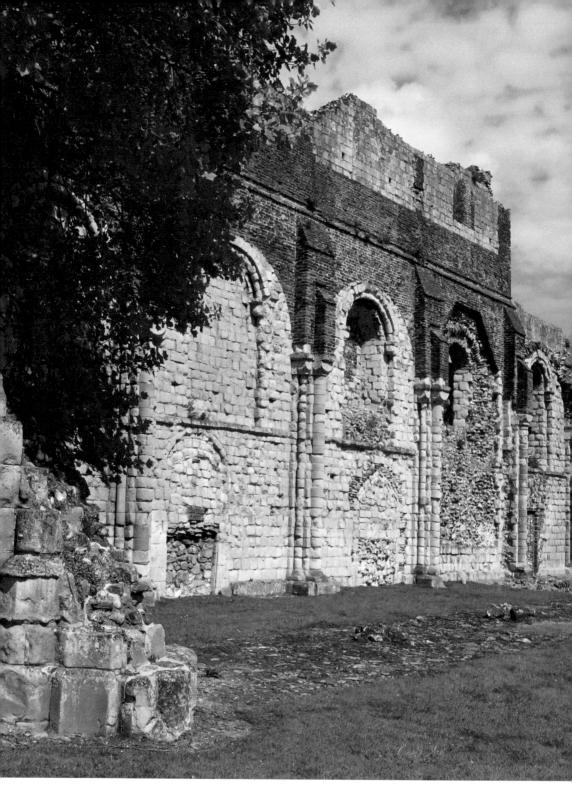

The surviving part of the north wall of the nave topped with Tudor brickwork when incorporated into the King's House built for Henry VIII.

Part of the abbey site redeveloped in the 1840s now forms part of the King's School.

St Augustine's Missionary College, preparing young men for work in the Empire's colonies. The college ceased to function in 1942, when it was severely damaged in an air raid. The remaining college buildings are now part of the King's School with the ruins of the abbey itself part of the UNESCO World Heritage Site, cared for by English Heritage and open to the public.

3. Canterbury Cathedral

The word cathedral comes from the Greek 'cathedra' meaning 'seat' and after his arrival in Canterbury, Augustine needed to create a building that could serve as the seat of his mission and become the centre of the Christian revival of Britain.

After Ethelbert's conversion he generously granted Augustine leave to build his cathedral on the site of what had been his own palace. This first cathedral was replaced by a larger building in the ninth or tenth centuries and during Dunstan's tenure as Archbishop from 960 to 988, the Benedictine abbey of Christ Church Priory was built on the north side of the cathedral. In 1011 the cathedral was damaged during the Viking raid which led to the death of Archbishop Alphege.

A catastrophic fire in 1067 destroyed what remained of the Saxon building and the first Norman Archbishop, Lanfranc, began the rebuild that same year using stone from Caen in Normandy. Cruciform in shape with a long nave and two towers at the west end, it was completed in 1077. Subsequent Christ Church priors continued to carry out improvements and developments, with Prior Ernulf's choir being renowned for the magnificence of its paintings and glass. The eleventh-century historian William of Malmesbury claimed 'nothing like it could be seen in England'.

In 1170 the cathedral witnessed an event that would change its history forever, when Archbishop Thomas Becket was killed in an area of the north-west transept now known as the Martyrdom. Becket and King Henry II had been engaged in a long-standing and increasingly acrimonious conflict over the rights of the Church in England, with Henry trying to curb the powers of Church courts who were responsible for trying any clergy who had committed secular crimes. Henry believed that the King's courts should stand in judgement in such cases, with his former friend Thomas arguing that the Church should maintain its power in these circumstances. Matters came to a head in December of 1170, when Henry is said to have asked in fury 'Who will rid me of this turbulent priest?' although more accurately he enquired angrily why his followers should 'let their lord be treated with such shameful contempt by a low-born clerk'. Four knights, hoping to gain favour with the King, headed from the Christmas court in France to find Thomas in Canterbury and bring him back to answer to Henry. On 29 December, after a heated altercation first in the Archbishop's Palace and then in the cathedral, the knights' rage got the better of them and Thomas was struck down, the final blow severing the crown of his skull so that his blood and brains spilled onto the flagstones.

Although Becket was by no means universally liked, his murder in what should have been the sanctuary of the cathedral shocked both Britain and Europe. The monks of Christ Church Priory instantly declared him a martyr. By 1173 Pope Alexander III had already made him a saint; the miracles being attributed to him brought increasing numbers to the cathedral and its place as a centre for pilgrimage was assured.

Fire again proved the cathedral's enemy in 1174 when a spark, possibly from a blacksmith's workshop in the precincts, set the choir roof ablaze, with much of the area below also being destroyed. Occurring only four years after Becket's murder, the disaster did, however, provide an ideal opportunity to create a new and bigger space more suitable for the saint's shrine, then housed in the crypt. The commission was given to a French master mason known as William of Sens and he arrived in Canterbury bringing with him a style of architecture new to England, now known as the Gothic. The choir's outer walls had largely survived but William had them raised by 3.7 metres and replaced the inner choir with high pointed arches, buttresses and rib vaulting. A boss bearing the Lamb and Flag at the east end of the choir marks the spot where William fell from scaffolding in 1179, a fall which he survived but brought an end to his life as a mason.

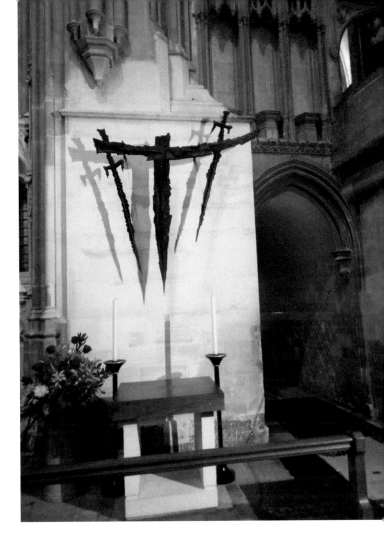

This altarpiece created by the artist Giles Blomfield marks the spot where Becket met his death, in the space known as the Martyrdom.

His place was taken by another William, known as the Englishman, and it is he who is responsible for the magnificent Trinity Chapel, a large ambulatory chapel to the east of the choir and immediately above Becket's original resting place in the crypt. Beyond the Trinity Chapel is the circular Corona chapel which housed the top of Becket's skull in a reliquary.

Becket's remains were moved to their new home in 1220 and for the next 300 years were central to both cathedral and city, bringing in substantial revenues from the crowds of pilgrims who visited the shrine. These revenues were instrumental in funding subsequent restorations and additions to the cathedral such as the rebuilding of the nave in the Perpendicular Gothic style in the late 1300s, together with the redevelopment of the priory cloisters and the building of what is England's largest monastic chapter house. In 1376 the body of Edward the Black Prince was placed alongside the saint's tomb to be followed later by that of Henry IV. The 1430s saw the construction of the 72-metre-high tower known as Bell Harry, with its impressive fan vaulting created by John Wastell, who later went on to supervise the building of King's College, Cambridge.

In 1538 Becket's shrine was destroyed on the orders of King Henry VIII as he began to break away from the Church of Rome in the process known as the Reformation. Christ Church ceased to be a priory having been a Benedictine monastery since the 900s and many of its buildings became part of what is now the King's School.

The next period of upheaval came during the English Civil War when between 1642 and 1643, ardent Puritans, led by one Richard 'Blue Dick' Culver, were responsible for the destruction of much of the medieval stained glass as well as the statue of Christ in the Christ Church Gate. When the monarchy was restored, the new King Charles II spent his first night home from exile in Canterbury. So shocked was he at the state of the cathedral, that he gave a large donation towards its renovation and the construction of new choir stalls.

There were no further threats to the fabric of the building until the Second World War, when it found itself the target of German bombers keen to attack major cultural sites in Britain. A group of fire wardens mounted a constant vigil

The cloisters to the north side of the cathedral were redeveloped in the late 1300s. There are some 800 bosses adorning the roof.

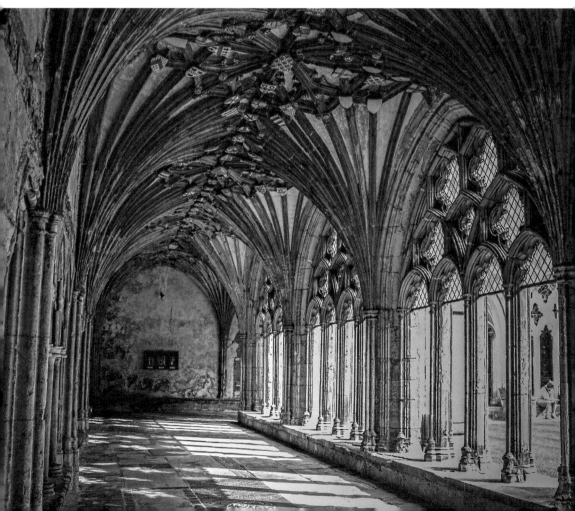

on the roof of the building in order to douse any fires started by incendiary devices dropped to guide incoming bombers. In 2005 a memorial to these fire watchers was placed near the south-west door, serving as a reminder to all who enter that the cathedral stands today thanks in no small part to their courage.

Between 2016 and 2021, the cathedral has seen its future assured in a major programme of restoration, funded by a multi-million-pound Heritage Lottery grant together with contributions from the Canterbury Cathedral Trust and the Friends of the Cathedral. This has allowed for the re-leading of the roof, the cleaning and restoration of stonework both inside and out, extensive restoration of the organ, and conservation of its stained glass, including the thirteenth-century Miracle Windows. Over a million visitors come to the cathedral each year and a new visitors' centre has been created to cater for those who follow in the footsteps of those who have come this way since the time of Augustine himself.

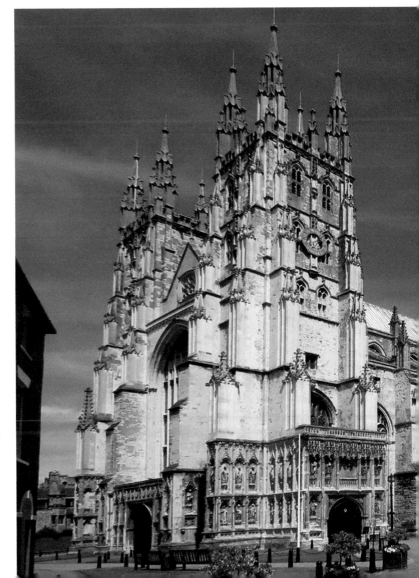

The cathedral represents the centre of the worldwide Anglican Communion and remains a working church with regular daily worship at its heart.

4. Roman Town House, the Roman Museum, Butchery Lane (AD 270)

Although little remains above ground of Roman Canterbury, the Roman Museum helps provide insights into life within their city. Foundations of several town houses have been discovered over the years with the museum being built on the site of one such dwelling.

In 1868 workmen digging a new drainage system in Butchery Lane came upon a remarkably well-preserved Roman mosaic over 2 metres below the road's surface, but it was not until the Second World War that the importance of this discovery was properly understood. As bomb-damaged buildings began to be cleared, more mosaics, wall paintings and a hypocaust (underfloor heating system) were gradually uncovered. It was clear that here were the remains of what had been a large and expensive Roman house.

Subsequent excavations were carried out between 1958 and 1962 which showed that the building had had a long history, beginning as a wooden structure constructed just before the coming of the Romans in AD 43. It underwent a variety of structural changes until by AD 270, it had become a large two-storey house built around a central quadrangle. The museum was constructed above the remains in order to preserve what is one of Britain's only in-situ Roman pavement mosaics and now designated as a Scheduled Listed Monument.

The museum contains many artefacts relating to Roman life in Canterbury.

Around AD 410, as the legions were recalled to Rome, an unknown individual buried a hoard of treasure near the London Gate, which remained undiscovered until roadworks in 1962. The hoard is on display in the museum with its most significant item a small silver knife or shellfish opener inscribed with 'PX', the Chi Rho symbol for Christ in Greek – evidence of a Christian presence in the city, well over a century before Augustine's arrival.

5. The City Walls, Roman and Medieval

The first defensive walls around the city were created by the Romans between AD 270 and AD 280. Around 6 metres high, they were made of local flint, faced with flint cobbles and reused stones from other demolished buildings; the round stones set high in the wall near Burgate are examples of these original materials. At least five gates were built into the walls, linked to the various roads leading in and out of the settlement. A rare full-height section of Roman wall can be seen near the north wall of St Mary, Northgate. Queningate car park is built on part of the ditch before the walls; excavations show this would have been 25 metres wide and 5.5 metres in depth, making it a considerable addition to the city's defences.

Below left: A portion of the original Roman wall remains, incorporated into the north wall of St Mary's Church.

Below right: Over half of the city walls survive, including a lengthy section enclosing the Dane John Gardens.

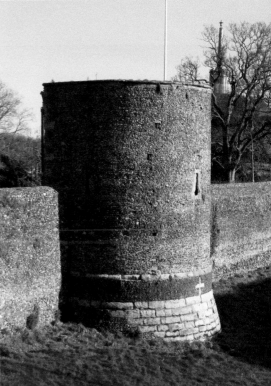

After the departure of the Romans, the Anglo-Saxons continued to use the walls for defensive purposes, at one time holding off marauding Vikings for twenty days. By the late fourteenth century England and France were engaged in the conflict that history knows as the Hundred Years' War and the citizens of Canterbury were keen to ensure that the now dilapidated walls be made fit for purpose. A report from 1386 found 'the walls of Canterbury are for the most part fallen because of age, and the stone thereof carried away'. By 1402 nearly all the city had been enclosed within the refurbished walls, with twenty-four towers added.

Demolition during the eighteenth and nineteenth centuries and bombing during the Second World War means that the city now has only around a third of its original circuit of walls left but they are a powerful visual reminder of how the city was once protected.

6. St Mildred's Church, Stour Street (c. 1030s)

At the end of Stour Street, in the south-west corner of the old city walls, stands one of only a very few pre-Norman churches in all of Kent. The date of

The nave of St Mildred's from the south, with the addition of the Tudor chantry chapel. The large quoin blocks are thought to be reused Roman stones.

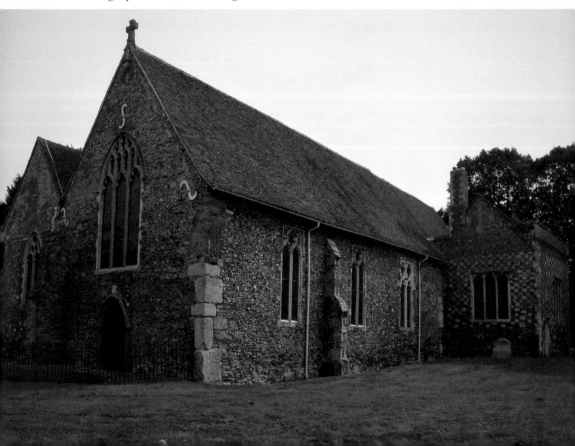

Above left: The chancel and crown post roof structure of the oldest church to be found within the old city walls.

Above right: The fifteenth-century font still retains its pulley-operated lid.

the original construction of St Mildred's is not known for certain but the two Anglo-Saxon walls in the nave point to the fact that a church stood here before the Normans arrived in 1066. The church is dedicated to Mildred, who, being the great-granddaughter of King Ethelbert and Queen Bertha, enjoyed close ties to Canterbury. On the death of her mother, Ermenburga, Mildred took over as Abbess of the convent in Minster on the Isle of Thanet; she became renowned for her wisdom, compassion and kindness to the poor, so that on her death sometime around AD 732, her tomb became a place of pilgrimage.

After the last Abbess of Minster was captured by Danes in 1011, Mildred's remains were eventually taken to St Augustine's Abbey in the early 1030s, so it is very possible that the church in her name was begun around that time.

It is built largely of Kentish flint and tile and contains some large quoin stones that would have had their origins in a Roman structure. Most of the nave and the side chapels were built between the thirteenth century and 1512. Much restoration work took place in 1861 and then again in the 1920s. The south-east chapel is especially interesting, made of Tudor flintwork and containing a large fireplace, presumably to warm those singing psalms for the souls of the Attwood family, whose chantry chapel it once was. One of the windows in the chapel contains an image of St Mildred in stained glass. The font, which dates from

1420, is a rare pre-Reformation example, complete with the original pulley system for raising the lid.

The church is used for services on a regular basis but is often shut outside of those hours, so it is best to check the website before visiting.

7. Canterbury Castle, Reims Way (twelfth century)

The Norman invasion of 1066 left William the Conqueror keen to stamp his authority on England by constructing intimidating castles that would dominate the landscape and act as a visual reminder of the new order.

Canterbury's location on the main Dover to London road meant it was of strategic significance, so soon after the invasion building work on just such a castle began in the city. For speed, the original construction was in the popular motte-and-bailey style, consisting of an earthen mound (motte) topped by a wooden or stone keep, surrounded by a spacious enclosed yard (bailey). In Canterbury's case, the motte was the existing mound at the south-east end of the old Roman walls. This had been a Romano-British cemetery and now found itself incorporated into the new Norman defences. The mound still exists in what are now called the Dane John Gardens, after 'donjon', the Norman word for a motte.

The castle keep dates from the reign of Henry I, and served for many years as a prison.

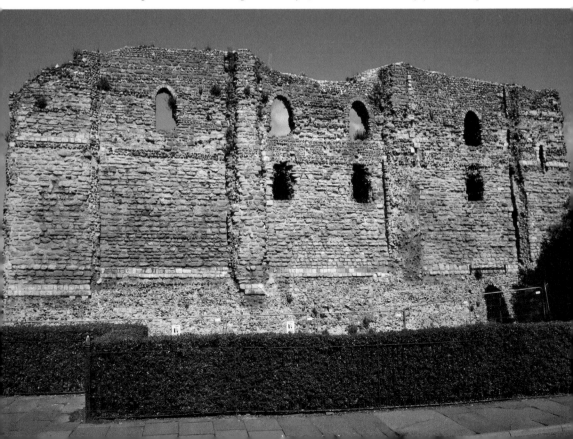

The Domesday survey of 1086 shows that eleven houses belonging to the church had to be demolished to make way for the castle.

The wooden structure was replaced during Henry I's reign in the early 1100s by an even more imposing sandstone and flint version. Its walls were 4 metres thick and a massive 30 metres × 24 metres in area, standing 24 metres high. It was the third largest keep in England, after the castles of Rochester and Dover; Henry II's redevelopment of the latter meant that by the end of the 1100s, Canterbury's castle became less important and by 1381, rebels of the Peasants' Revolt felt sufficiently emboldened to attack the castle and cause considerable damage.

Repairs were carried out under the supervision of master mason Henry Yevele, who clearly had his hands full, as he was also working on the Westgate and the cathedral nave. From the thirteenth century the castle became a jail until entering private hands in 1609. Its fabric began an inexorable decline with upper sections of the keep being demolished in 1770 and the bailey wall removed in 1792. In 1825, it was sold to the Canterbury Gas Light and Coke Company who used it to store coke, adding to its disrepair. Since 1928, the castle has been in the ownership of the City Council and closed to the public since 2018 due to its dangerous condition.

8. Norman Staircase, Green Court (*c.* 1160)

This flight of eighteen stairs was built around 1160, during the time of Prior Wibert, and gave access to what was known as the High Hall, which originally housed guests to the priory and subsequently provided shelter for pilgrims. It is

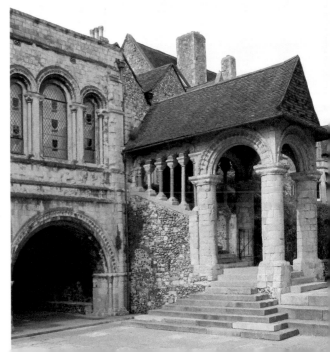

Now an entrance to King's School classrooms, the Norman staircase originally led to a guest hall for poor pilgrims.

thought to be the only existing external twelfth-century staircase in England and is in remarkably good condition. The base has four columns with Norman capitals and arches and there is a balustrade formed by rectangular columns known as pilasters. Decorations such as chevrons and dogtooth carvings on the pillars are clearly reminiscent of those on the Water Tower.

The High Hall was demolished in the eighteenth century, but the staircase survived and now leads to King's School library, with schoolrooms having been built above the arches in the 1850s. A sketch of the staircase by J. M. W. Turner exists in the Tate archives.

The ashes of writer W. Somerset Maugham were scattered in a garden near to the stairs; Maugham was a pupil at King's in the 1880s but was so unhappy there he refused to go back on reaching his sixteenth birthday, which makes it a somewhat surprising location for his final resting place.

9. Prior Wibert's Water Tower, Cathedral Grounds (twelfth century)

Wibert was Prior of the Benedictine community of Christ Church Priory during the 1150s and 1160s and the water tower attributed to him is an unusual example of medieval monastic engineering.

Although the monks did not indulge in regular bathing, it being thought unnecessarily luxurious, their rule did require them to wash before meals and at the start of each day. To facilitate this, Wibert set about providing a ready supply of fresh water and his plan, dating from around 1165, can be seen in a surviving document known as the Eadwine or Canterbury Psalter, held in the library of Trinity College Cambridge.

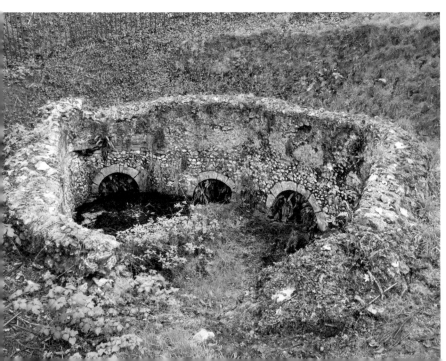

This conduit house was built in the thirteenth century to supply water to both St Augustine's Abbey and the cathedral, fed by nearby springs.

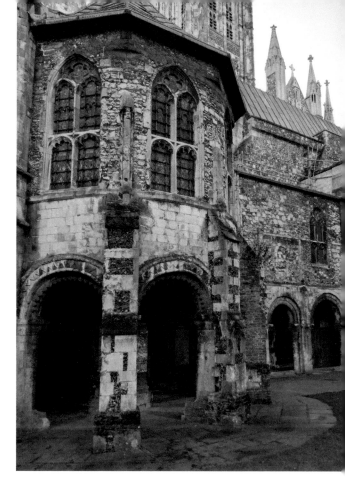

At the cathedral end of the system Prior Wibert built an octagonal water tower to allow distribution around the monastery.

The fresh water had its source around a kilometre away in a pond in what is now King's Park, near North Holmes Road. It was then fed through a series of pipes and settling tanks until it reached the storage tank within the octagonal tower that still stands today, in what was once the infirmary cloister. It has been estimated that around 10,000 litres of fresh water were delivered to the monastic precincts every hour, providing not only water for washing but also for drinking, brewing, cooking and the removal of waste.

The storage tank within the octagonal chamber was, in fact, a large brass bowl with eight spigots and a central fountain, in a style that seems a little exotic for its location. In 1465, the bowl (or 'laver') was removed by Prior Goldstone and the room is no longer used for its original purpose.

10. The Westgate (fourteenth century)

The Westgate is the only one of the city's defensive gates left and is the largest medieval city gate in the country. It's possible that it was designed by Henry Yevele, the mason already working on the new cathedral nave at the instruction of Archbishop Simon of Sudbury. It consists of two 18-metre drum towers of

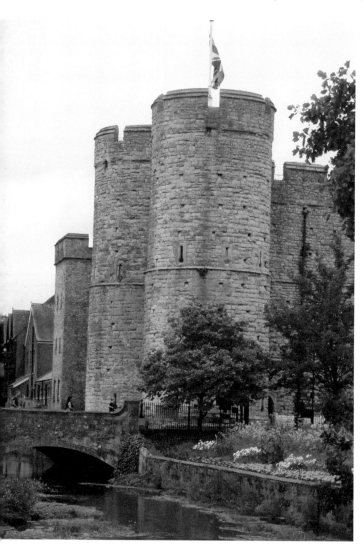

Traffic now flows across the river and through the arch of Westgate, where a drawbridge was originally installed.

Kentish ragstone flanking a Gothic archway set in a square frame. The archway would have been protected by a portcullis and a further defence would have been the River Stour running in front of the gate. The holes for the drawbridge across the river are visible in the stonework.

The building is of special military significance as it not only has traditional battlement openings or machicolations allowing defenders to hurl projectiles and boiling liquids upon the unfortunate heads of would-be attackers, it is also the first English structure to contain gun-loops. These key-shaped holes in the walls were specifically designed for the deployment of newly invented cannon.

None of the above defences seem to have been deployed in 1381, when Wat Tyler and his followers entered Canterbury, during the Peasants' Revolt, searching for Sudbury. He was also England's Chancellor and many ordinary people blamed him

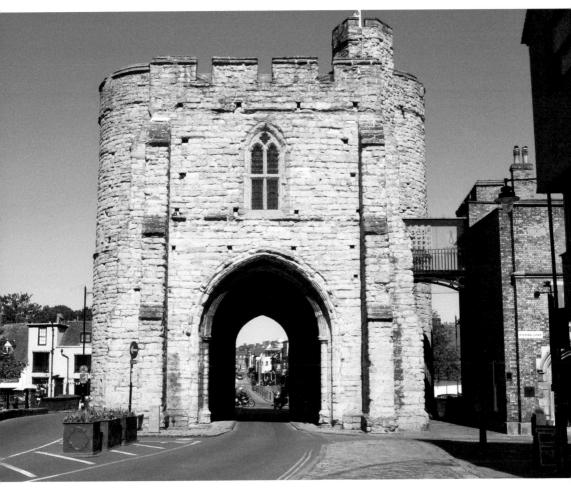

Looking from the city through the impressive gateway towards St Dunstan's Street.

for the poll tax levied to replenish the coffers after Edward III's lengthy military campaigns in France and Spain. Sudbury was in London, however, where the rebels finally found him at the Tower and executed him in brutal fashion. The Westgate was unfinished and the less sophisticated construction of its top floor and parapet hints at the city losing both funds and enthusiasm for the project after his death.

By 1453, Westgate had become a prison with its key-loops blocked to prevent escape and the portcullis remodelled as the top of the condemned cell in the main room above the road. In its time, it housed many felons as well as some of the Protestant martyrs burned at the stake during Mary I's reign, in the area now known as Martyrs' Field Road. Its use as a prison could well be the reason it survived when the other six city gates were demolished between 1787 and 1830.

Today it is open to the public as a museum and its neighbouring building, the Pound, once the city police station, is a bar where customers can enjoy a drink in one of the refurbished cells.

11. Conquest House, 17 Palace Street (eleventh century onwards)

Architectural historian John Newman, in his *Buildings of England*, dismisses this one as being of 'unpromising-looking phoniness'. What appears to be a typical sixteenth-century frontage with its half-timbering and jettied windows is indeed 'phony' having been created in the nineteenth century, but such a verdict is, perhaps, harsh when the long history of the house behind the frontage is considered.

The Norman undercroft shows that a house has stood here from the eleventh century; some of the stone walls from that time remain and amongst the flint can be found traces of flat Roman bricks, most likely from the remnants of the city's Roman road.

In 1170 the house belonged to Gilbert the Citizen and it is from here that, traditionally, the four knights left to confront Becket, using a tunnel that supposedly ran from the undercroft to the Archbishop's Palace across the street.

The house contains a fourteenth-century galleried hall where travellers would, somewhat ironically, have been able to find accommodation when visiting Becket's

The rebuilt façade of Conquest House, derided by John Newman.

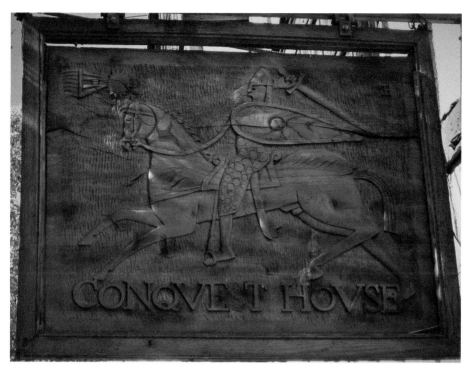

A hint of the significant part played by Conquest House in the murder of Thomas Becket may be gleaned from this sign.

shrine. The ground-floor front room was originally a courtyard and contains a highly decorative fireplace from the seventeenth century bearing a coat of arms made in honour of the marriage of Charles I to Henrietta Maria which took place in the cathedral in 1625.

In recent years, the building has been, amongst other things, an antiques centre, an art gallery, a café and an environmentally friendly grocery shop.

12. The Blackfriars in Canterbury (thirteenth century)

In 1237, the Benedictines and Greyfriars were joined by a group of Dominicans, known as the Blackfriars, after the colour of their robes. Henry III granted them land to the west of the city, where modern-day Blackfriars Street and the Marlowe Theatre are now found. The King also provided £500 and timber for the project, enabling the monks to construct a substantial priory built around a cloister, including a dormitory, guest house, church and refectory, the whole complex spanning the River Stour.

In 1538, the priory went the same way as all other monastic foundations in Henry VIII's campaign of dissolution and its buildings were either destroyed or used for a variety of purposes. The guest hall was used as a weaving shed by

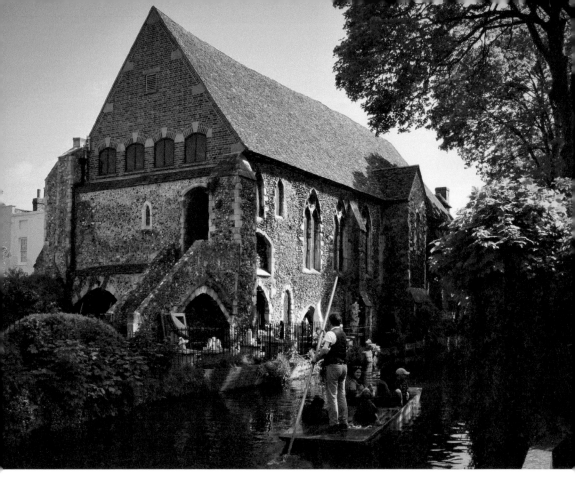

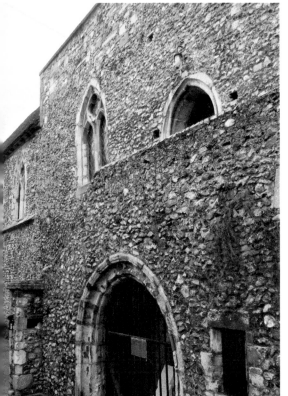

Above: One of just two surviving buildings
from the Blackfriars foundation, the
old refectory is now an art gallery for
King's School.

Left: The east façade from Blackfriars Street.

Huguenots, becoming a private residence in the 1780s and a furniture store in 1905. This increasingly dilapidated structure was bought by a local couple, Mr and Mrs Beerling, in 1979, who restored it and today it is used as a community hall and scout hut. The refectory remains on the eastern side of the river and was an Anabaptist chapel from 1640 to 1912. It was given to King's School in 1982 and is now an art gallery.

13. The Greyfriars, Stour Street (thirteenth and fourteenth centuries)

By the thirteenth century the Benedictines of Christ Church were not the only monastic order to be found in Canterbury. In 1208 Francis of Assisi had founded an order of mendicant, or begging, friars who sought to live lives of poverty and humility whilst ministering to the growing numbers of urban poor. In 1224, during Francis' lifetime, a group came to England to extend this work, with around four of their number settling in Canterbury.

The friars lodged in accommodation to the rear of Eastbridge Hospital until the Pope ordered them to acquire property in order to carry out their mission more effectively. The friars themselves were forbidden from owning property as they were pledged to lives of poverty, so the City authorities provided 18 acres of

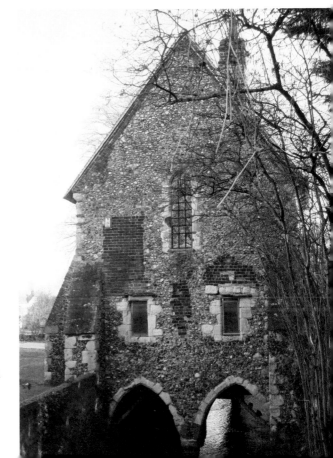

The remaining dormitory of the Franciscan House straddles a branch of the River Stour.

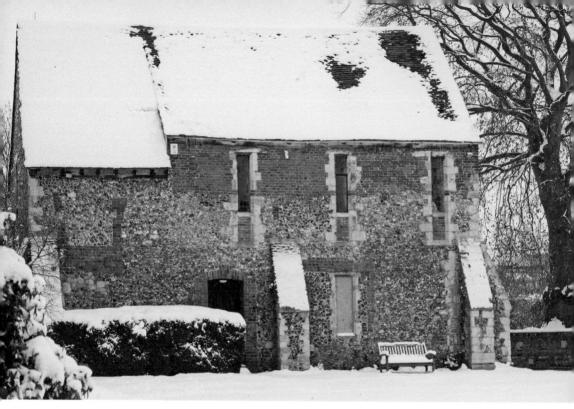

Thought to be the oldest surviving Franciscan building in the UK, it enjoys a picturesque setting. (Image courtesy of Randi Hausken)

marshy ground behind the hospital, which was drained, with a large stone friary being erected between 1267 and 1325. This was dedicated to the work of the Franciscans although not owned by the Order.

After the Dissolution of the Monasteries in the 1540s, the friary passed through many hands and over time, its constituent buildings were demolished, and the stonework robbed out. All that remains is a structure over the River Stour that has been, at various times, a private home, a gaol, a tea-room and a market garden. Having been acquired by the Dean and Chapter of the cathedral in 1959, it is now used as a chapel by the Anglican Franciscan movement, with services taking places every Wednesday at 12.30, with members of the public welcome to attend.

Now maintained as the Franciscan Gardens, with an entrance tucked away in Stour Street, it is an unexpectedly tranquil open space only a few metres from the High Street.

14. Eastbridge Hospital, 25/26 High Street (1190)

Becket's murder had an immediate effect upon Canterbury. Increasing numbers of visitors to his cathedral shrine created a pressing need for accommodation; this knapped flint building on the High Street was amongst the first to be built with such needs in mind.

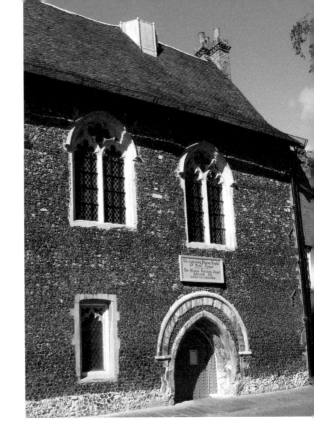

Right: The knapped flint frontage with Norman arch housing a Gothic door.

Below: Originally a dormitory, the refectory undercroft dates from the twelfth century.

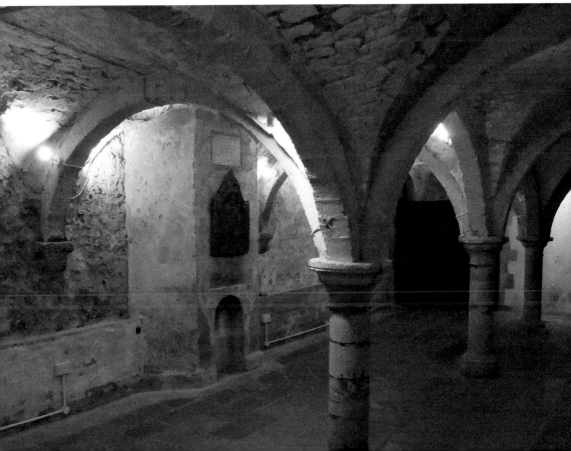

In 1190 local merchant Edward FitzOdbold founded the Hospital of St Thomas the Martyr on the east bridge across the Stour. It was not a hospital in the modern sense but simply a place of hospitality providing bed and board. The undercroft served as the dormitory, divided into bays, where up to twelve visitors slept on straw mattresses.

It seems to have been intended as somewhere for poorer pilgrims to find lodgings and was under the care of a master who oversaw its upkeep. A list of these masters can be seen on a board in the first-floor refectory and the four names between 1349 and 1351 are a reminder of the impact of the Black Death during these years.

In 1361 Sir John Lee gave 180 acres of land in nearby Blean, as well as nine cocks and twenty-one hens, to Eastbridge 'for the increase of works of piety', demonstrating that the hospital's charitable work was ongoing well over a century after its founding, and despite the difficulties of the plague years.

A fourteenth-century list of hospital regulations states that it should provide a single night's shelter for poor but healthy pilgrims at the cost of 4 pence. Sick pilgrims were to be given preference and allowed a longer stay; lepers were excluded, however.

The remarkable king strut and scissor braced roof of the chapel.

The destruction of Becket's shrine in 1538 brought the steady flow of pilgrims to a halt and in 1569 the building became a school, which it remained until 1861. It is thought that the playwright Christopher Marlowe may have been a pupil prior to his time at King's. In 1584, almshouses were created within the building which offered homes for ten poor but deserving citizens.

The building suffered periods of neglect but in the late 1960s, land in Blean that had been part of the 1361 endowment was sold to the University of Kent enabling necessary repairs. Today, eight elderly residents of Canterbury, known as in-dwellers, live in the restored almshouses and the fourteenth-century chapel is open for contemporary visitors wishing for a few moments' quiet contemplation.

15. Cogan House, 53 St Peter's Street (1200 onwards)

There has been a building on this site from around 1200, when it was the home of Luke the Moneyer. It retains its original Norman undercroft; the 0.76-metre-thick clay and stone west wall in the front part of the building date from the same period.

By 1203 its next owner, William Cokyn, had died and instructed that it become a hospital in the manner of Eastbridge Hospital. The appropriate alterations were

Below left: The west wall, of stone with chalk, is thought to date from the twelfth century.

Below right: An example of sixteenth-century panelling still visible in today's restaurant.

made but it was never as successful as Eastbridge and in 1230 that institution took it over, renting it for many years to mayors and aldermen of the city.

In the Tudor period, John Thomas became its owner; in 1528, he installed some finely carved wooden panelling depicting not only the tools of his trade as a hosier but also images of his favourite pursuits of hunting and bear-baiting. The ground-floor kitchen and dining room of the Tudor house are in use today as part of an Italian restaurant.

In the late 1500s some highly decorative plasterwork was created and in 1626 the building was further enhanced when John Cogan (who may have been descended from Cokyn) added the impressive central staircase. Also remaining are costly wooden panels, carved with images of vines and grapes. On his death, Cogan requested that the building become a home for the 'habitation of six poor widows of clergymen' from the Canterbury diocese and it served such women well for the next two centuries.

By 1870, it was in the hands of a tailor named Thomas Wells who converted it to a shop, had the Tudor wooden jetties removed and replaced with a brick frontage. In the twentieth century, it spent a period as a private residence before being made into a restaurant, its external appearance giving little hint of its long history and fascinating interior.

The Victorian shopfront to Cogan House effectively disguises what is probably the oldest secular house in the city.

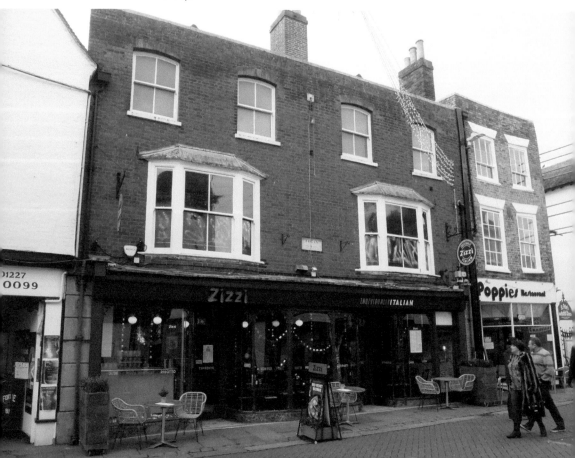

16. Fyndon Gate (fourteenth century)

The main gateway to St Augustine's Abbey, this impressive structure with its two octagonal towers dates from the era of Abbot Thomas Fyndon, who held office from 1297 until 1309. Behind the gate lay the great court of the monastery, which he developed following the grant of a charter in 1300. The area above the gate itself was the abbey's state bedchamber – even being used by Charles II on his return from France in 1660, long after the Dissolution.

After many years in private ownership, the site was acquired in 1804 by the appropriately named William Beer who established a brewery adjoining the gate. However, the adjacent buildings that can be seen today behind the gate were built,

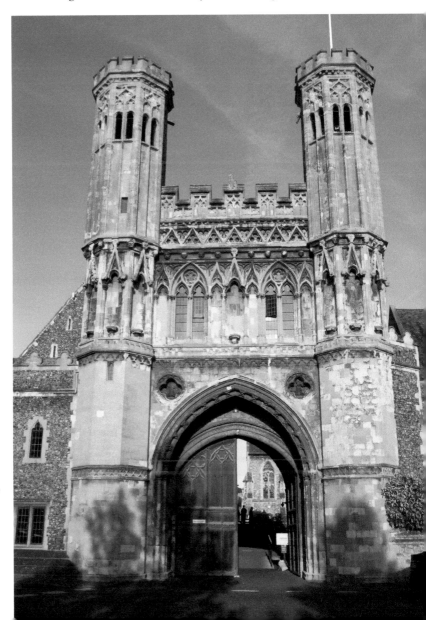

The early fourteenth-century Great Gateway to St Augustine's Abbey built by Abbot Fyndon.

with a certain monastic character, in the mid- nineteenth century as a missionary college, which closed in 1947, and now form part of King's School.

The gate faces onto Lady Wootton's Green, named after Margaret Wootton, a seventeenth-century resident of St Augustine's Palace, and previously known as Mulberry Tree Green. The houses overlooking the south side of the Green are a post-war development replacing bomb-damaged buildings. Statues of King Ethelbert and Queen Bertha are prominent features of the Green where Bertha can look toward the Queningate where she once used to walk on her way to services at St Martin's Church.

17. The Hall, Ivy Lane (fourteenth century)

This is a fine example of a Wealden hall house and one of the oldest houses in the city. It is of a style particular to south-east England, timber-framed with a central open hall. The hall is flanked by jettied two-storey bays to either side. It was built in 1380 and survived as a single dwelling until well into the seventeenth century when it was used as an inn. In the eighteenth century it was divided into four separate cottages, known as 42–45 Ivy Lane. In 1959 the cathedral architect Tony Swains took on the considerable task of returning the hall to its original configuration and restoring its external appearance.

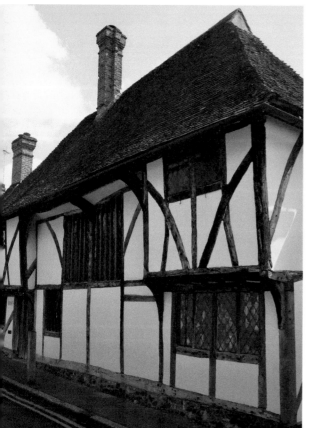

Above: Jettied end bays are characteristic of the Wealden Hall house.

Left: The recessed central bays, without projection, enclosed the full-height main hall.

18. Chequer (Cheker) of Hope, Corner of High Street and Mercery Lane (twelfth century)

It is likely that an inn was founded on this site around the time of Becket's murder in 1170 to shelter the pilgrims who almost immediately began to journey to the city in search of a miracle.

The square, three-storey building was rebuilt and extended in 1392 and is an indicator of the city's prosperity during this period. The work was undertaken by Christ Church Priory to provide additional accommodation for pilgrims whilst providing extra income for the monastery. There are two suggestions for its unusual name. The first is that it comes from the board game played at the inn on tables made of beer barrels (tuns) stood on end and held together with hoops (hopes) of iron. The second is that it refers to the counting house or Cheker building in the priory.

It was a substantial building taking up half the west side of Mercery Lane and would have been a busy one. A basement allowed ample storage for the workshops on the ground floor, whose shopfronts offered a variety of goods and

Only part of the ground-floor stone arcade survives, but the jettied upper floors give an impression of the extent of the original building.

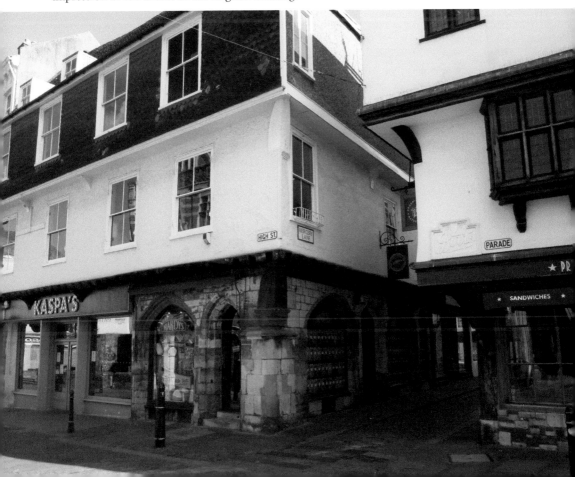

Badge detail, or cognizance, thought to represent the Black Prince.

services to visitors. The first floor catered for wealthier pilgrims, with larger and more comfortable rooms. An external gallery enabled them to look down on to the interior courtyard. Under the rafters of the second floor was a large, open dormitory for the use of up to 100 poorer visitors, without the luxury of any private space.

The inn gets a mention in *The Tale of Beryn*, an addition to Chaucer's *The Canterbury Tales* written by an anonymous poet in the fifteenth century who says 'They toke hir inn, and logged hem at midmorowe, I trowe, /Atte "Cheker of the Hoop," that many a man doth knowe.'

The inn also appears in municipal records in 1592, when local boy Christopher Marlowe was involved in a brawl with the tailor William Corking outside the hostelry. He attacked Corking with a staff and dagger and, not surprisingly, the irate tailor reported this assault upon his person. Marlowe's unrepentant response was to press charges in return although both cases were eventually dropped.

Most of the western end of the building was destroyed by fire in 1865 and its life as a medieval pilgrims' hostel is hard to distinguish today. A dragon beam in the shop that occupies the space together with a heraldic badge, possibly that of the Black Prince, on an external corner are but poor reminders of its past.

19. St John's Hospital, Northgate (eleventh century)

In 1085 Archbishop Lanfranc provided an annual £70 endowment for the provision of housing for the weak and ill of Canterbury and the necessary dwellings were built on a site near the Northgate. Originally, the hospital catered for some eighty residents who were cared for by priests from the priory of St Gregory the Great, which stood opposite. Most of the early buildings were destroyed by fire in the fourteenth century although a chapel with twelfth-century features remains and is still used for services twice weekly. The toilet block or reredorter has also survived and has the distinction of being considered England's oldest lavatory.

Entry to the hospital is through an impressive Tudor gateway which leads to a group of four nineteenth-century houses facing onto a green. The Tudor kitchen, now a lounge, faces the green with the Tudor refectory above. The Reformation

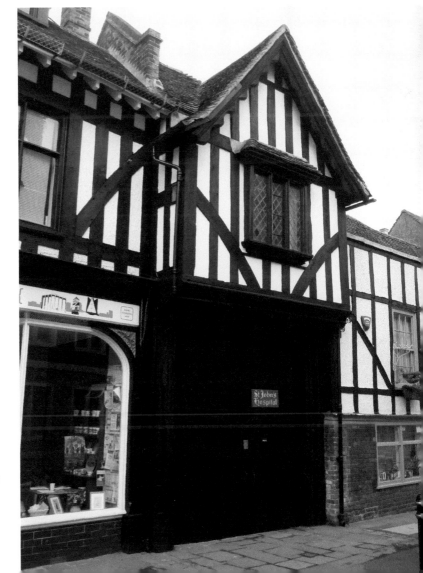

The gatehouse fronting Northgate dates from Tudor times.

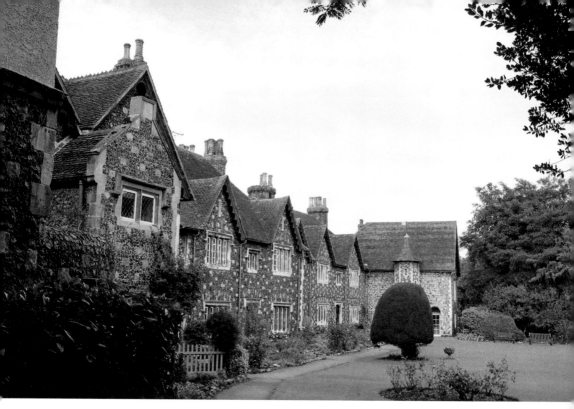

Nineteenth-century almshouses partially overlap the site of Lanfranc's original building of 1084. The seven-sided turret staircase is worthy of note.

saw the destruction of St Gregory's Priory, but left the hospital untouched, if without priests to care for the inmates.

Despite this, the hospital survived to carry on its charitable work and now, 900 years after its founding, elderly residents still live in what are probably the oldest almshouses in England. The hospital is not open to the public.

20. The Parrot Pub, 1–9 Church Lane (fourteenth century)

This is amongst the oldest secular structures in the city, dating from the late 1300s. Built on Roman foundations, using Roman bricks in places, it stood just inside their original city wall and is another excellent example of a timber-framed Wealden hall house.

It began life as St Radigund's Hall, in honour of the monks of the same name, based near Dover. The original open hall eventually had a first floor created above it with chimney stacks being added in the fifteenth century, indicative of wealthy owners. The rear roof angles visible from the internal courtyard suggest that another building was joined to the property at some point.

Whatever happened during the intervening centuries, by 1937 the building was in imminent danger of demolition. Years of being used as a tenement house containing individual small apartments, explaining its address of 1–9 Church Lane,

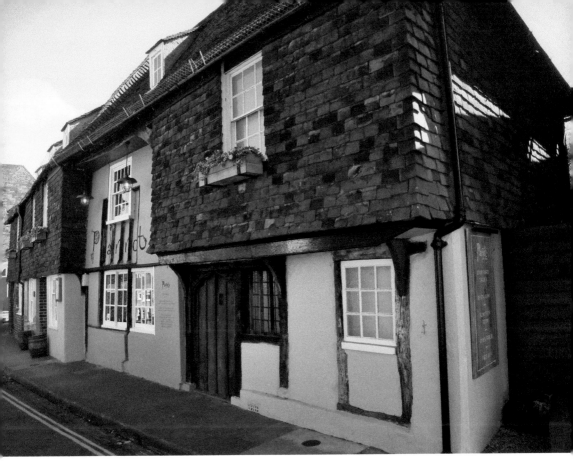

Above: As at Ivy Lane Hall, the jettied end bays indicate the typical Wealden Hall origins of the Parrot.

Right: The Parrot rear courtyard.

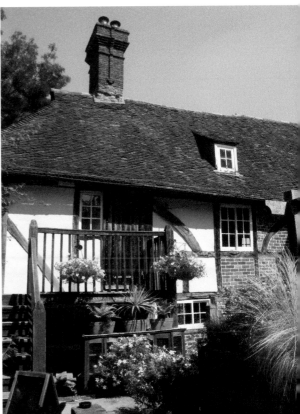

had left it in a poor state of repair and deemed unfit for habitation. Fortunately, the uncovering of features such as the 1470 staircase frames led to a change of heart by city authorities; the building was spared and a programme of restoration begun.

It was used for a variety of purposes until 2008, when it was purchased by Young's Brewery and is now a pub and restaurant.

21. The Guildhall (twelfth century onwards)

From the twelfth century, groups of merchants and craftsmen began to come together in organisations intended to promote and protect their individual and collective interests whilst exerting some degree of local political influence. In many ways, these guilds, as they were known, operated much like the trade unions of today, providing financial assistance to members in need, funding apprenticeships, maintaining standards of production and so on. The word 'guild' comes from the Anglo-Saxon 'gilden' which means to 'pay' or 'give up' and each member was required to contribute a certain amount each year for the work of the guild as well as helping to maintain their meeting place, known as the Guildhall.

In Canterbury, the Guildhall stood on the same site on the corner of High Street and Guildhall Street for 770 years. Today, the site is occupied by a coffee shop and its unexciting exterior gives no hint of the medieval remains to be found inside.

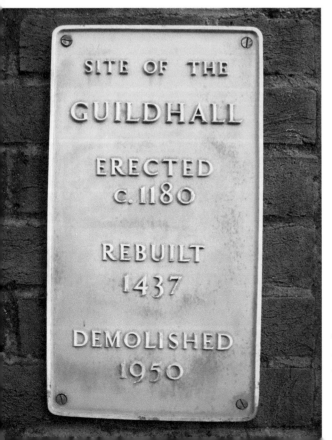

The site of the city's old Guildhall, demolished in 1950, is now a coffee shop.

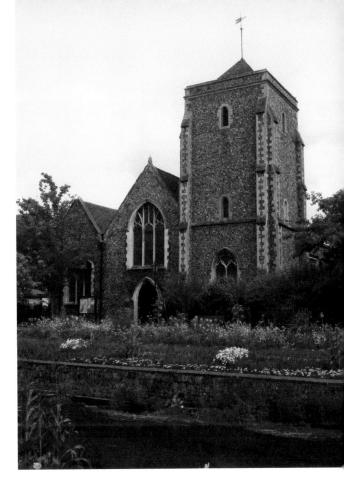

The present Guildhall, adjacent to the Westgate, was formerly the Church of the Holy Cross, erected by Archbishop Sudbury, and deconsecrated in 1972.

The basement is a stone undercroft dating from the twelfth century and above this are the remains of six bays dating from the fourteenth century. It underwent various restorations and alterations over the years, with an ornamental brick façade being added on the Guildhall Street side in the 1700s and a stone frontage to the High Street added in 1835. In 1765, it is thought that the boy Mozart played here during his European tour.

As in many places, when the guilds ceased to exist, the building became the home of the town council and magistrates' courts, but by 1948 it was in a state of advanced disrepair. For two years, the council debated its future, with the necessary repairs being so expensive it was cheaper to knock it down and rebuild from the bottom up. The size of the building, however, meant it was no longer fit for purpose so creating an exact copy made this proposal unviable, especially in the cash-strapped post-war city. It was finally demolished in 1950, in what the *Kentish Gazette* described as 'unseemly haste'.

Today's Guildhall is situated in what was once Holy Cross Church by the Westgate, part of Archbishop Sudbury's building programme of the late 1370s. The church had been made redundant by the Church Commissioners in 1972 and donated to the city. It was refurbished internally in 1978 and is now the meeting place of the City Council.

22. The Buttermarket and Christ Church Gate (medieval period onwards)

The area of the city known as the Buttermarket has been a gathering place for centuries and is one of the modern city's busiest spots, full of tourists and locals alike enjoying the surrounding pubs, restaurants and shops. In the medieval period, when it was known as the Bullstake, it was perhaps a less pleasant place in which to loiter. Here bulls would be tethered to a stake and baited by dogs in the belief that the resultant meat would be more tender when sold by vendors in the nearby shambles of Butchery Lane. 'Now and then an infuriated animal broke from the stake … followed by shouting butchers and by yelling dogs, scarcely less savage or brutal than their masters' writes John Brent in *Canterbury in the Olden Time*.

A cross also stood on the site during much of this period and was used as a whipping post for the more penitent pilgrim. In 1471 the city's mayor, Nicholas Faunt, was executed here for backing a failed Lancastrian assault upon London by opponents of the Yorkist Edward IV.

In 1664 brothers John and William Somner provided funds to create a market hall and it is then that the area became known as the Buttermarket. Traders rented

The city's war memorial now takes centre stage in the Buttermarket.

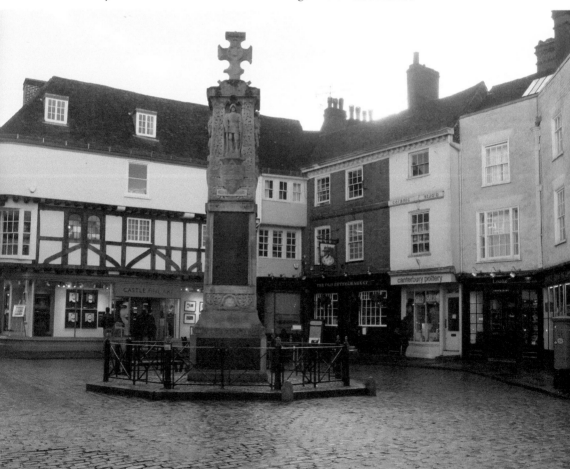

ground-floor spaces whilst the upper level was used for the unlikely combination of grain storage and theatrical entertainments. By the end of the 1790s with the original timber badly decayed, the city corporation rebuilt the hall as a roofed space supported on sixteen pillars at a cost of £450. This structure too fell into disrepair and was demolished in 1888.

In 1893 a statue of a female muse was unveiled in the square by renowned actor Sir Henry Irving, to commemorate Christopher Marlowe. Many felt her scanty clothing inappropriate for a location so near to the cathedral and when in 1921 it was decided that this would be a suitable location for the city's memorial to the fallen of the First World War, 'Kitty' was removed to Dane John Gardens and in 1983 to the front of the Marlowe Theatre, where she still resides.

The Buttermarket is dominated by Christ Church Gate, the main entrance to the cathedral precincts. Despite an inscription dating it to 1507, it was built between 1504 and 1521 with money provided by Priors Goldstone and Goldsworthy. It was probably constructed to honour Prince Arthur who had married Katherine of Aragon in 1501. Arthur died the following year and the throne came to his younger brother, who ruled as Henry VIII taking Katherine as his first wife. The arms of Aragon, Castille and the Tudors combine as decorative features.

Below left: An inn sign, however, gives an indication of its former importance as a central marketplace.

Below right: Christ Church gate, the primary entrance to the cathedral, dominates the Buttermarket.

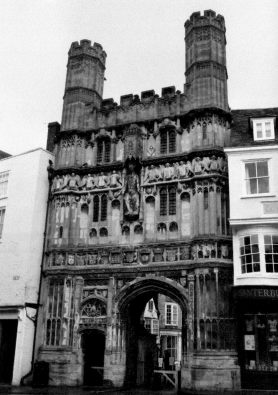

The original wooden gates and statue of Christ were destroyed by Puritans in 1643 although the gates were restored in 1660 by Archbishop Juxon. In 1803, Alderman James Simmons complained to Mr White, the surveyor of the cathedral, that he could not see the cathedral clock from his bank on the High Street (now a branch of Lloyds). In an extraordinary act, White had the original gate towers demolished to solve the problem. Fortunately, in 1937, they were replaced thanks to the efforts of the newly formed Friends of Canterbury Cathedral and in 1992, a statue of Christ was once more placed over the gate.

23. St Dunstan's Church, St Dunstan's Street (eleventh century onwards)

Dunstan was Canterbury's Archbishop from AD 96 to AD 978 and was instrumental in reviving monastic life in the country. He was canonised swiftly after his death and his remains buried in the cathedral where they rested until his shrine was destroyed at the same time as Becket's in 1538.

Dunstan was renowned as a skilled metalworker and became the patron saint of jewellery makers. For 600 years the Assay office had its hallmarks run from 19 May (his birthday) to 18 May in the following year.

St Dunstan's, where Henry II changed into his sackcloth on his penitential pilgrimage to the cathedral in 1174.

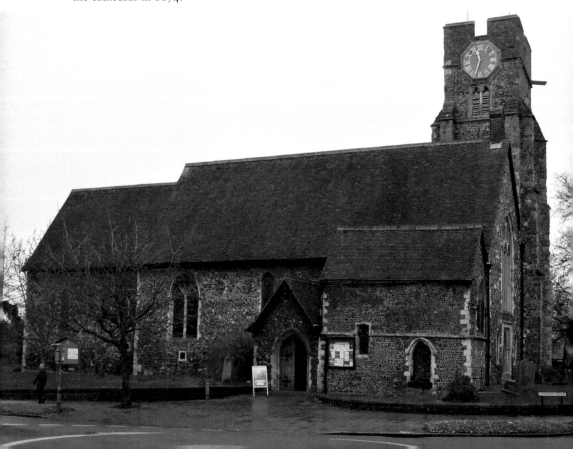

There are several legends connected to Dunstan; in one story Dunstan encounters the Devil but undaunted, he pinches Satan's nose with red-hot blacksmith's tongs. He pinches with such ferocity that the Devil screams loudly enough to be heard for miles around.

This Grade I listed church dedicated to Dunstan dates from the eleventh century and sits on the corner of London Road and Whitstable Road. For many pilgrims, it would have been their last stop before reaching the cathedral. One such visitor was Henry II, who stopped here in 1174 when on his penitential pilgrimage to Becket's shrine. He changed into sackcloth in the church and from there walked barefoot to the cathedral.

The building he would have entered has been altered over the centuries, with the addition of a chantry chapel in the fourteenth century and a south aisle and new windows in the fifteenth. In 1525, a further chantry chapel was built by the Roper family and is one of the first structures in the city to use the red bricks that became a distinctive part of Tudor architecture.

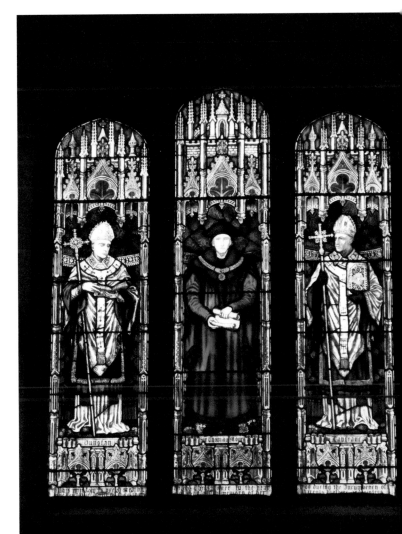

The window depicting, from left to right, St Dunstan, Thomas More and Archbishop Lanfranc was installed in 1909.

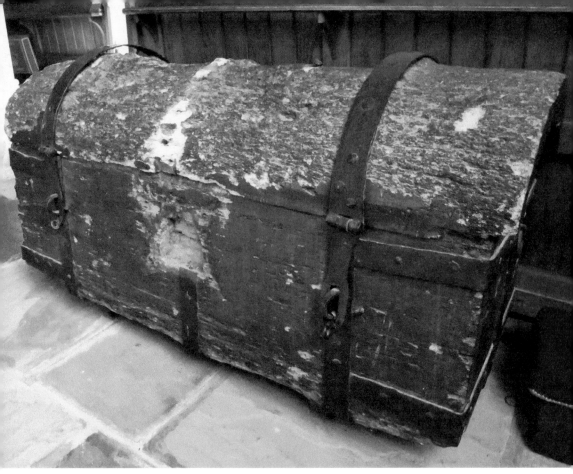

Once used to hold alms for the poor of the parish, this chest dates from the fifteenth century.

The Ropers were a wealthy local family and William Roper was married to Margaret, the daughter of Sir Thomas More who was executed by Henry VIII for refusing to sign the Act of Supremacy declaring the King to be the head of the Church in England. She is said to have reclaimed her father's head from a pike above London Bridge and had it interred in the Roper vault in St Dunstan's. A large stone slab to the left of the Roper chapel alter marks its location and More's story is told in the twentieth-century stained-glass windows above.

24. The Roper Gateway, St Dunstan's Street (sixteenth century)

Will Roper was MP for both Rochester and Canterbury between 1529 and 1558 as well as being High Sheriff of Kent from 1554 to 1555. The status of the family was reflected in their grand home, Place House, reached by means of this imposing entrance.

It consists of a stepped gable with a triple light window and is a fine example of the style of brickwork that became synonymous with Tudor building. It is made of small, mainly red bricks laid in alternate courses of headers and stretchers, in

The crow stepped gable is a feature of the Roper Gateway, which once led to Place House.

the method known as English bond. Darker bricks created by over-firing are used randomly throughout in diamond shapes and are characteristic of the period.

In 1797, Flint and Co. set up a brewery on the site with access to the premises via the old gateway. For many years, an image of the gate appeared on the labels of Flint bottled beers. The company ceased trading in the 1920s and the former brewery buildings were demolished in 1957. The gateway is all that is left of both Place House and the local firm that traded from the site for so long.

25. Queen Elizabeth's Bedchamber, 44/45 High Street (fifteenth century)

Between the fifteenth and the eighteenth centuries the building on this site was known as The Crown Inn and it is here that, in 1573, Elizabeth I supposedly spent three nights whilst entertaining her suitor, the Duc d'Alencon. In fact, it is probable that she stayed in the Archbishop's Palace, a far more fitting location for the monarch than a public house; whatever the case, her time with her unsuccessful French admirer is the origin of the song 'Froggy went a -courting'.

The current building dates from the late sixteenth century and is a three-storey jettied construction with the addition of a decorative façade in the seventeenth century and dormer windows in the eighteenth.

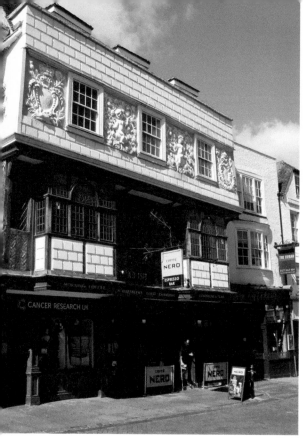

Left: The front elevation of 44 and 45 High Street displays some very fine pargetting.

Below: A detail of two of the seventeenth-century pargetted panels. The scenes depicted relate to the building's use as an inn.

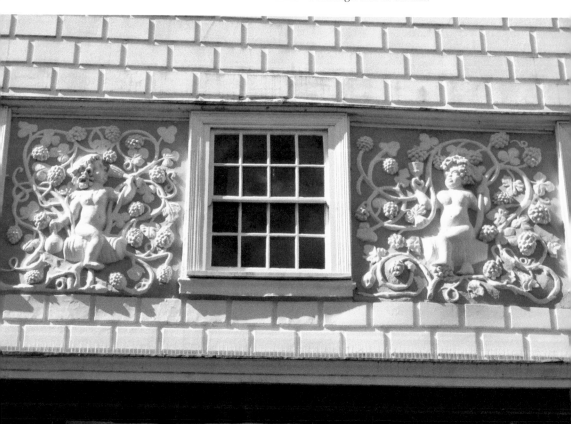

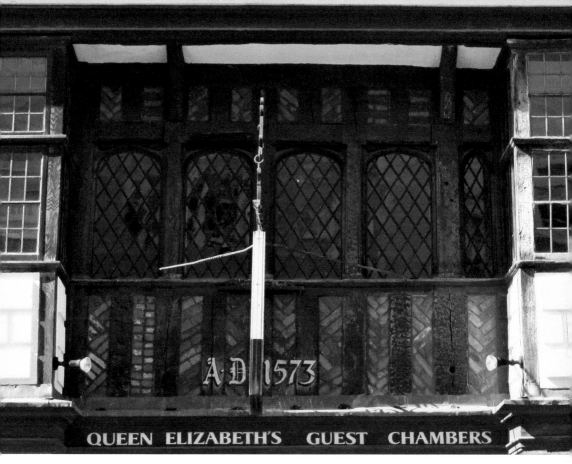

The date 1573 refers to the occasion that Elizabeth supposedly stayed here.

The first floor is partly plastered and partly timber-framed with brick infills in a striking herringbone pattern. The elaborate plasterwork on the second floor is known as pargetting; it includes two plaster side panels dating from 1663 with blank shields topped by roses, crowns and thistles. The two central panels have images of a naked cherub or 'putto' sitting atop a barrel, surrounded by grapes whilst drinking wine. Such costly decoration suggests that the building was in the hands of some affluent owners during these years, perhaps using the story of Elizabeth to bring in the visitors.

During the nineteenth and twentieth centuries, the building played host to varied businesses, including a bootmaker, a tea warehouse, a meat store and a greengrocer. It became Queen Elizabeth's Tearooms in the 1940s and operated as such for many years; at the time of writing, it is a branch of Caffè Nero.

26. Fordwich Town Hall (sixteenth century)

Fordwich lies on the River Stour north-east of the city and is the smallest community in the UK to boast a town council. Although described in the Domesday Book as a small village, it prospered as an important port in medieval

times, and Caen stone used in the cathedral was landed here. It became a limb of Sandwich, one of the Cinque Ports, but gradually the Wantsum Channel silted up, making the town inaccessible from the sea with a subsequent loss of trade.

However, Fordwich remained a town until 1880, when it lost its right to appoint a mayor and corporation. Remarkably, this right was restored following local government reorganisation in 1972. The mayor and the town council now meet regularly in the sixteenth-century town hall, said to be the smallest in the country. The Mayor is also Mayor Deputy of Sandwich, a tradition which preserves the link with the Cinque Ports.

The town hall of 1544 dates from Henry VIII's reign and probably took the place of an earlier example. The first floor is a courtroom, used as such until 1886; the pleading bar remains, with a small jury room to one side. The Mayor was judge by virtue of office.

On one corner at ground-floor level is the jail, with adjacent quarters for the jailer. The jail's last occupants were three local men convicted of poaching trout in 1855 – each serving fourteen days.

An unusual feature of the town hall is the hand-operated crane at the rear of the building, which could be used to move goods to and from boats moored on

Reputedly the smallest in the country, the Town Hall at Fordwich still serves its community.

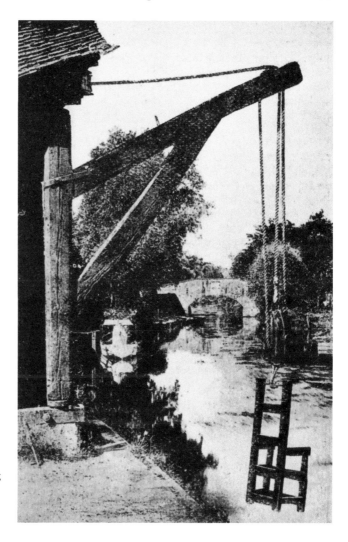

Built alongside the River Stour, the Town Hall featured a ducking chair as a form of punishment. (From authors' collection)

the river alongside. From time to time it would have been used with the 'ducking chair' – a punishment for hapless women convicted of gossiping or some other misdemeanour. The ducking chair itself survives but happily is no longer in use.

27. All Saints' Court (sixteenth century onwards)

Dating from the sixteenth century, All Saints' Court had originally been a rest house for Eastbridge Hospital. Later converted into cottages, by the early 1900s it was in very poor condition. Other medieval buildings in the lane had already been demolished as part of a slum clearance programme and the court was destined for a similar fate, until a local builder named Walter Cozens intervened, undertaking the necessary restoration.

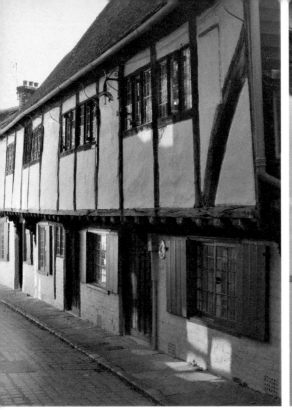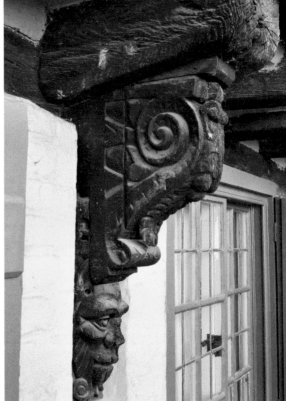

Above left: The continuous overhang is an impressive feature of 'All Saints' Court.

Above right: One of seven decorated corbels.

After time spent as a youth hostel and then a dance school, in the twenty-first century it is once again a private residence which boasts an upper storey consisting of a single long room. The house is L-shaped with a timber frame and a Kentish peg roof. The seven decorated corbels, which may have originated in St Augustine's Abbey, are a striking visual feature.

28. Weavers' Houses, Turnagain Lane (sixteenth century)

Religious persecution of Protestants in the Low Countries during the reign of Elizabeth I caused large numbers to flee to England and many settled in Canterbury. Well known as highly skilled weavers, the Queen granted them permission to establish businesses in the city and by the end of the sixteenth century over 1,300 refugees were at work in the area. Elizabeth also granted them permission to worship in a chapel in the cathedral crypt; the Huguenot Chapel still offers services in French.

Their houses were notable for the upper-storey workshops, with windows the full width of the front elevation to allow as much daylight into the working area as possible. There are various buildings with such features around the city with the finest examples being the run of houses in Turnagain Lane.

The full-length workshop windows are a distinctive feature of weavers' houses.

A second influx of refugees arrived from France in the second half of the seventeenth century; these Huguenots, as they were known, were also weavers, specialising in fine silks rather than the worsted of the earlier immigrants. Many of Canterbury's Huguenots moved to London to find a wider market for their luxury products, but others stayed so that in 1665 nearly 2,000 weavers were still to be found.

29. Old Weavers, High Street (1500)

As the name makes clear, another structure with a direct link to the city's once flourishing textile trade is this house adjacent to the river: the date displayed above the door is 1500 although a structure of some sort has stood here for considerably longer. City records from 1574 remark on the prosperity the 'Strangers' had brought to Canterbury and it seems to be around that time that the building began to be used by them.

In the first half of the eighteenth century, cheap imports had brought the local trade to crisis point but in 1787, John Calloway developed a versatile cotton/silk mix fabric which became known as Canterbury Muslin. It proved very popular and kept the industry alive until the beginning of the nineteenth century when imports of Indian cotton finally sounded its death knell.

By 1889 the building had been divided into various retail outlets including a dairy, a laundry and the Golden Lion Inn. However, that was not quite the end

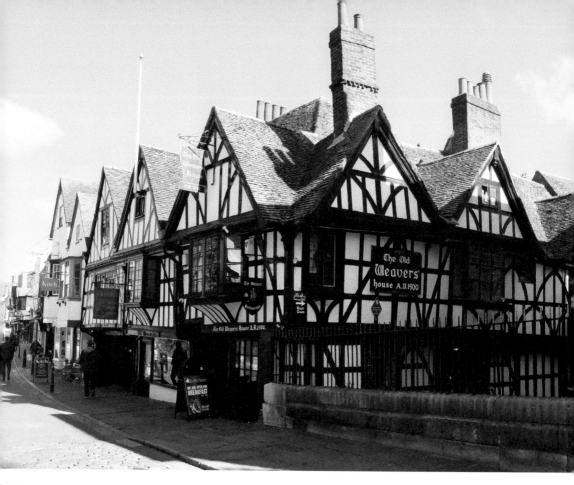

Above: One of the city's most prominent and well-known buildings, the Old Weavers has enjoyed a variety of uses in its lifetime.

Left: The river elevation showing three original gables and the two later additions.

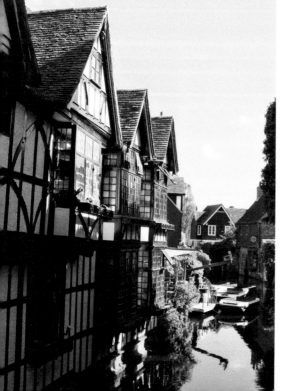

of the weaving story as, in 1897, during the era of the Arts and Crafts movement, Misses Edith Holmes and Constance Philpott established a weaving school 'for women and girls in need of work'. Starting with just three looms, the enterprise expanded to employ thirty women using as many looms. The upper-floor workshops were open to the public each day, and by 1922 when the business had passed to a Mrs J. Wood, the tuppence admission charge offered the visitor the opportunity to inspect 'Afternoon Tea Cloths, Sponge Bags, Tweeds and Linens in the course of manufacture'.

Today the building is the home of The Old Weavers restaurant and the river elevation with its black and white timber, five gables and mullion windows is one of the most recognised views in the city.

30. Memorial to Forty-one Kentish Martyrs, Martyrs Field, Wincheap (1899)

Although not strictly speaking a building, the memorial is included here as a reminder of the religious persecution that took place in England during the sixteenth century and the toll it took on so many.

If Henry VIII left his mark on the city with the destruction of Becket's tomb and Christ Church Priory, his daughter Mary I also brought suffering to Canterbury during her attempts to return her realm to the old faith. Many Protestants who refused to revert to Catholic worship found themselves sentenced to be burnt at the stake. Canterbury was the site of more such burnings than anywhere other than London with forty-one suffering this agonising death between 1555 and 1558. Some prisoners were held in the jails in the castle and Westgate before being

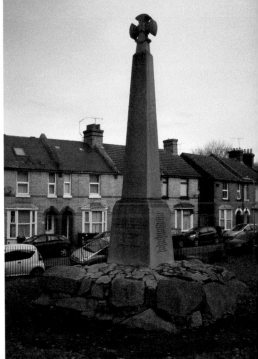

Right: The Martyrs' Memorial erected in 1899, over 300 years after the event commemorated.

Below: The inscription honouring the forty-nine Protestants martyred at the site.

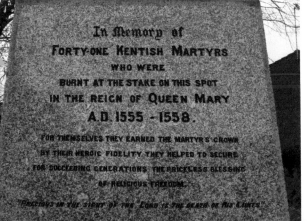

In Memory of
FORTY-ONE KENTISH MARTYRS
WHO WERE
BURNT AT THE STAKE ON THIS SPOT
IN THE REIGN OF QUEEN MARY
A.D. 1555 - 1558.
FOR THEMSELVES THEY EARNED THE MARTYR'S CROWN
BY THEIR HEROIC FIDELITY THEY HELPED TO SECURE
FOR SUCCEEDING GENERATIONS THE PRICELESS BLESSING
OF RELIGIOUS FREEDOM.
"PRECIOUS IN THE SIGHT OF THE LORD IS THE DEATH OF HIS SAINTS."

taken to the stake at what was then an open space beyond the city walls, in the area known as Wincheap.

In 1890 workmen came across the exact site when they found a pit containing large numbers of charred human bones. In 1899 enough money had been raised by public subscription to erect a monument on the site; it is over 7.5 metres tall, of grey granite, surmounted with a Canterbury cross. This distinctive rounded cross was designed to echo a Saxon brooch found in the city in 1867. The names of all the forty-one who died are listed on the side.

These were not the only individuals who were executed in the city for their faith, however. In 1588 four Catholics were hanged, drawn and quartered at Oaten Hill, off the Old Dover Road, for their refusal to adopt Protestantism. Contemporary accounts speak of them going to their deaths with great courage and in 1929 they were beatified by Pope Pius XI. Although the city has not yet accorded them a memorial, it seems right to acknowledge that they, too, died for what they believed in.

31. 28 Palace Street (1617)

With its crooked doorway, 28 Palace Street is undoubtedly one of the best-known buildings in the city and certainly one of the most photographed. It is sometimes

Below left: The distinctive front elevation of 28 Palace Street.

Below right: A corbel detail.

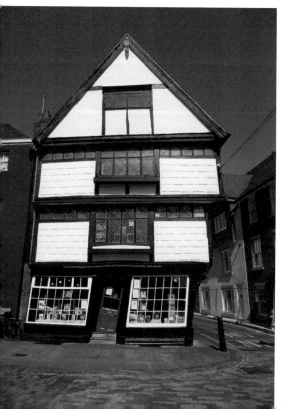

The building has not always leaned so dramatically, but the front door has clearly been adapted to suit!

referred to as John Boys' house, after a one-time Canterbury MP, although the link is doubtful given that Boys died in 1612 and the apparent construction date noted on the top gable is 1617.

It was more probably built by the Huguenot cloth merchant Avery Sabine, whose initials appear on the gable apex. This area was, at the time, occupied by many 'strangers', as the Huguenots were often described, and the house shows signs of the wealth men like Sabine made in the years following their arrival in the city. The small side windows are known as clerestories and were designed to be looked out of without being seen from the street.

The timber-framed house is three and a half storeys high with the dramatic lean resulting most probably from alterations to the central brick chimney in the early nineteenth century. In 1988 this same chimney collapsed necessitating urgent structural work in order to prevent the building's total collapse.

For many years, the building was the uniform shop for King's School and now houses a bookshop.

32. House of Agnes, 71 St Dunstan's Street (sixteenth century)

In the medieval period, St Dunstan's was one of the main thoroughfares for pilgrims heading into the city and numerous inns lined the street catering for them. It is quite possible that the building that originally occupied the site was just such an inn; indeed, the building remains a guest house even if rather fewer of today's patrons are on a pilgrimage.

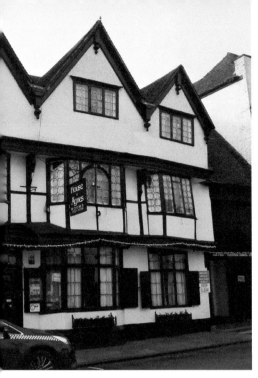

Above: A detail of the seventeenth-century windows.

Left: House of Agnes viewed from the busy St Dunstan's Street.

The attractive three-storey, timber-framed construction dates from the sixteenth century and served as a coaching inn during the eighteenth and early nineteenth centuries. The gateway once used by coaches still leads to the rear courtyard and to what is now Canterbury's largest walled garden. Charles Dickens visited Canterbury regularly and the building's unusual name derives from his description of Agnes Wickfield's home in *David Copperfield*, as a 'very old house bulging out over the road; a house with long, low lattice windows bulging out still further'. There is no definitive evidence that this is the building Dickens had in mind, but local tradition has cemented the story into fact; so much so, that in 1934, David O. Selznick and George Cukor chose it as a location when filming the first on-screen version of the novel, visiting the house themselves to check its suitability.

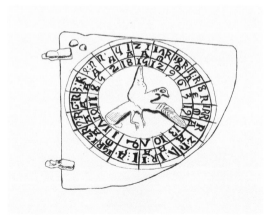

Found in the grounds of House of Agnes, this astrolabe is one of only eight known to date from the Middle Ages.

Archaeologists have discovered evidence that well before medieval times, the site had been the location of both a Roman pottery kiln and a graveyard. It has been suggested that a skeleton buried just outside the graveyard may have been that of an individual who did not follow the Christian faith of later Romano-Britons, and thus was not entitled to be interred in the cemetery itself.

In 2005 further excavations at the rear of the property unearthed an extremely rare late fourteenth-century navigational device known as an astrolabe, one of only eight ever found in the world and the only one made in England; interestingly, Chaucer wrote a *Treatise on the Astrolabe* in 1391, which is regarded as the first scientific work written in English. Called the Canterbury Quadrant, this object is now, appropriately, on display in the British Museum.

33. The Sun Hotel, Sun Street (fifteenth century)

Although Charles Dickens never lived in Canterbury, he knew it well. Annie Fields, the wife of his American agent, writes of how she 'explored the city under Dickens' direction' and attended evensong at the cathedral with him. There are at least seventeen references to Canterbury in his works, many of them in *David Copperfield* and The Sun claims to be 'The Little Inn' of the novel, where David sees Mr Micawber waiting for something to 'turn up'. Despite this being proudly displayed on a plaque on the wall, there are those who suggest that Dickens may have had an earlier Sun Inn in mind, which stood next to the Christ Church Gate, on the site of the cathedral's visitors' centre.

Right: The Sun Hotel, just a few yards from the Buttermarket and the medieval commercial heart of the city.

Below: The plaque describing the link with Charles Dickens.

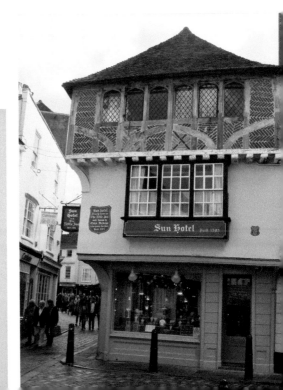

Sun Hotel
Formerly known as
The Little Inn
made famous by
Chas. Dickens
in his travels thro' Kent
Built 1503

That same plaque states that the building dates from 1503 although it was, in fact, built in 1480. Despite the confusion, its herringbone brickwork is typical of the period in general and its internal beams are also authentic. In 1865 it survived a fire that destroyed many adjacent buildings, as well as some in the High Street. Its fortunes declined in the twentieth century and by the time new owners took it over in 2006 it had been standing empty for fifty years.

During the twenty-first-century restorations, a tunnel was discovered running directly from the inn to the cathedral; its purpose is unknown although it does suggest that clergy did not always lead lives wholly devoted to prayer!

34. Jesuit Chapel, Tenterden Drive (1760s onwards)

This intriguing little structure was originally built as a belvedere in the grounds of Hales Place, a large house constructed in the 1760s for one of Kent's richest families. On the death of Edward Hales in 1837, the mansion passed to his one-year-old daughter, Mary.

She was educated in a French convent and subsequently became a Carmelite novice in Paris. Adopting a rather cavalier attitude to the vows of obedience and

The Jesuit chapel is built mainly in flint and brick, with blocks of animal bone.

poverty, she returned to Hales Place intending to build a convent there. It proved a failure and by 1880 she was bankrupt and sold off much of the estate to Jesuits from Lyons who used it as a college until the mid-1920s.

The belvedere had been used as a dovecote until Mary had it converted into a chapel where the Jesuits later placed her bones and those of her parents. Any remaining buildings on the estate were demolished between 1928 and 1929 and the land used for modern housing, but the circular chapel with its brick and flint construction remains, its 3-metre diameter decorated with animal knuckle bones.

35. Cooper Almshouses, Lower Chantry Lane (1900)

This row of six one-storey cottages with their elaborate Dutch end gables is not named in honour of Thomas Sydney Cooper of artistic fame, but rather acknowledges one Thomas Sankey Cooper and his brother, Henry.

Thomas lived from 1818 to 1898, a surgeon who entered local politics and became mayor of Canterbury in both 1866 and 1875. His obituary in the *British Medical Journal* of 1898 describes him as a man 'of a generous disposition, and

The Dutch-style gables of the Cooper almshouses are shown to advantage here.

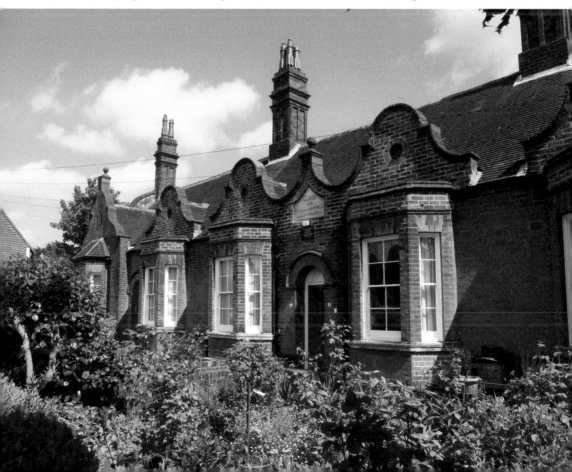

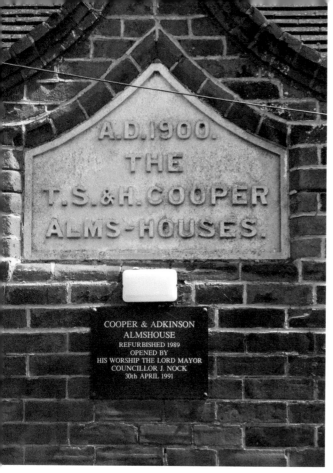

The founders' commemorative plaque.

always ready to help in cases of genuine necessity'. This generosity of spirit doubtless encouraged him towards the building of these small but attractive dwellings.

By so doing, he followed a long charitable tradition of providing almshouses within the city for the poor and elderly; Eastbridge Hospital, Jesus' Hospital in Northgate, and Manwood's almshouses are amongst others that have provided a home for Canterbury's most needy for hundreds of years.

In 1987 the Cooper charity amalgamated with another similar body, the John Adkinson Trust, which had been established in the early eighteenth century for the relief of poor widows in the parish of St Paul. The cottages were refurbished and recommissioned in 1991.

36. Beaney House of Art and Knowledge, High Street (1899)

Originally known as the Beaney Institute, the building houses a library, art gallery and a museum. Named after the its benefactor Dr James Beaney, it first opened its doors on 11 September 1899. Beaney was born in 1828 in Northgate Street and the death of his father only a few years later meant the boy was obliged to work

from an early age to help support the family. He became a 'surgery boy', working for several medical practitioners including William Cooper, brother of the artist Sidney. At some point he emigrated to Australia for a year where he worked for a chemist. He returned and gained his MRCS qualification in Edinburgh. There followed stints as an army surgeon in Gibraltar and the Crimea, where he worked with Turkish forces.

In 1857 he returned to Australia with his wife and became an extremely successful, if controversial figure. He pioneered new techniques in paediatrics, family planning and sexual medicine and published, amongst other works, Australia's first medical textbook. His publishers sued him some years later claiming that much of the writing was that of an assistant, which led some to question his medical qualifications. In the 1880s he became a member of the Victoria Legislative Council where his love of flashy jewellery earned him the nickname 'Diamond Jim', amongst whispers his wealth was acquired through carrying out illegal abortions.

He died, unabashed, in 1891 leaving £10,000 to establish the 'Beaney Institute for the Education of the Working Man' in his native city; presumably the fate of its women was of less interest. The City Council added a further £5,000 for the

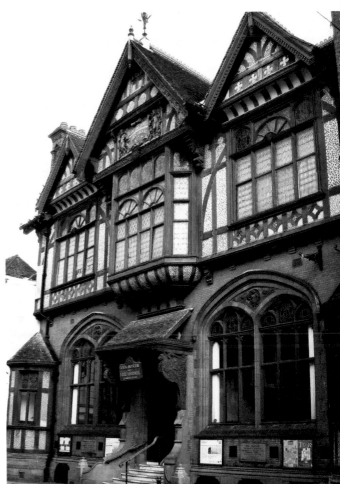

The Tudor Revival-style of the Beaney Institute by architect A. H. Campbell.

inclusion of a library. Architect and surveyor A. H. Campbell designed the Tudor Revival-style building, with its elaborate mosaic frontage.

An £11.5 million refurbishment, between 2009 and 2012 saw the installation of lifts, disabled access and gallery extensions. The art collection includes work by local artist Thomas Sidney Cooper, a sixteenth-century portrait of Chaucer and a Van Dyck painting of Sir Basil Dixwell, bought by the city for £1 million in 2004. Other collections include local archaeological discoveries, plus ceramics and oriental porcelain.

37. Sidney Cooper Gallery, High Street (nineteenth century)

Thomas Sidney Cooper (1803–1902) became Canterbury's most famous artist, and many of his works are displayed today in the Beaney Museum & Gallery with others in London's Tate Gallery.

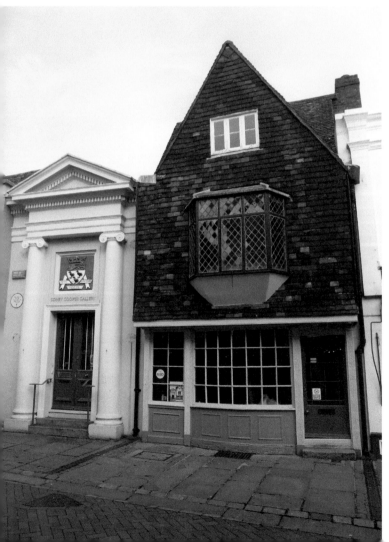

The Ionic portico of the gallery, and to its right the former Cooper family home.

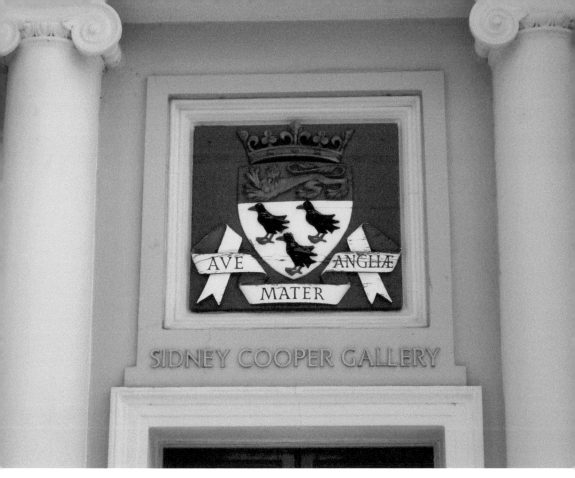

The plaque commemorating Sidney Cooper.

His family lived close to the Westgate in St Peter's Street and he began his artistic career as both a coach and scene painter. Aged twenty, despite the lack of any formal training, he was admitted to the Royal Academy. He eventually returned to Canterbury and became increasingly well known, particularly for his images of farm animals. In 1868 he established a gallery, which later became the Canterbury College of Art and School of Architecture. Mary Tourtel, the creator of Rupert Bear, was a student here in the late 1900s.

With a striking narrow entrance dominated by two pillars with Ionic portico, the design was not universally popular; in fact, the famous architect and designer Augustus Pugin described it as 'a Grecian temple outraged in all its proportions and character'. Regardless, in 1883 Cooper presented it to the city, and it now forms part of Christ Church University.

38. The Goods Shed, Canterbury West Station (nineteenth century)

A reminder of Canterbury's railway heritage is to be found at the Goods Shed. Built around 1860 of red brick with yellow-brick additions, it is striking for its blind arches topped with semi-circular lights.

Left: One of the blind arches with glazed toplights, built to maximise available daylight, even with loading bay doors open, as shown here.

Below: Despite the change of use, rails are still in situ through the building, as can be seen here.

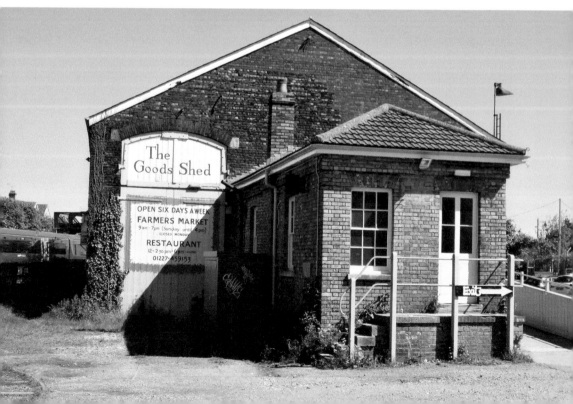

For much of the nineteenth and twentieth centuries goods traffic on the railways was far more lucrative than its passenger services. The railways were vital for transporting goods and materials around the country and required sheds and warehouses for their storage and distribution. These buildings are largely overlooked, however, especially as road haulage has taken over most of the freight industry.

It is likely that not a single goods shed in the country is now used for its original purpose and urban development threatens the existence of many. Canterbury's Goods Shed was listed in 1986 and now houses a high-end farmers' market selling a variety of local produce which can also be enjoyed in its nationally rated restaurant.

39. Tyler Hill Tunnel (nineteenth century)

As early as 1823 a railway line was promoted to link Canterbury to Whitstable and when it opened in 1830 it was the first line in southern England to use stationary steam winding engines, together with steam locomotives.

A direct route was chosen, with three steep inclines, and level sections between them, rather like the design of a canal. Tyler Hill Tunnel, at 757 metres long, was its major engineering feat, designed by George Stephenson. Trains were rope hauled through the tunnel in its early days, and later its narrow bore severely restricted the choice of suitable locomotives, resulting in the use of specially allocated engines with cut-down cabs and chimneys. Train crews working the line referred to the route as 'Working the Bung' because of the tunnel's restrictive size.

Always intended as both a freight and passenger service, the line holds the distinction of being the first in the world to issue a season ticket, which it did in 1834 to enable passengers to visit Whitstable's beaches during the summer season.

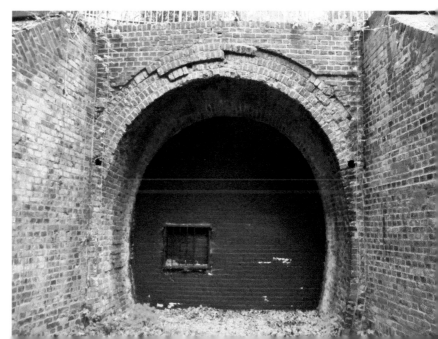

The northern portal of Tyler Hill tunnel. Both ends have been bricked up and the bore largely infilled following the 1970s collapse.

The Crab and Winkle Line, as it is often referred to, always struggled to pay its way and was taken over by the South Eastern Railway, eventually becoming part of the Southern Railway in 1923. This did not save it, however, and passenger services ceased in 1931. Freight services continued, including the transporting of munitions to Whitstable Harbour during the Second World War, but it finally closed for good after the floods of 1953 with the track lifted and the tunnel left to its own devices.

In July 1974 one of the university buildings collapsed and had to be demolished. The tunnel beneath was found to be the reason, so the bore was partially filled in and the two portals bricked up, perhaps a sad fate for one of the world's first passenger railways.

The railway's first steam locomotive, *Invicta*, dating from 1830, has survived, and in summer 2019 was moved from Canterbury to a new home in Whitstable Museum.

40. Canterbury West Signal Box (1928)

The first of the two railway lines serving Canterbury was the South Eastern Railway which opened in 1846. Its station became Canterbury West after the arrival of the London, Chatham & Dover Railway in 1860. The two companies later merged to form the South Eastern & Chatham Railway, which in 1923 became part of the Southern Railway.

The overline signal box replaced two earlier structures at West station in the 1920s. To the right is the goods shed.

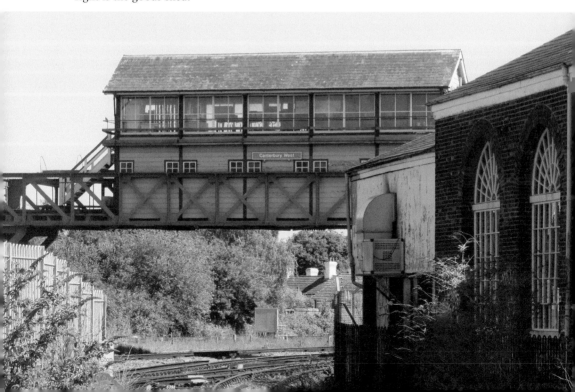

In 1874 the SER had equipped Canterbury West station with two signal boxes to control the four main running lines, Whitstable branch junction and associated yards and sidings. In 1928 the Southern replaced both with a new box, built on a gantry straddling the four main lines at the eastern end of the station. It is possible that the wooden structure of the signal box was moved from Blackfriars Junction and re-erected.

Despite the modernisation of the national network's signalling systems, with many signal boxes made redundant, Canterbury West signal box has survived into the era of the high-speed service from the Kent coast to London.

41. Weighbridge Cottage, North Lane (nineteenth century)

The original Canterbury & Whitstable Railway terminus had been situated in North Lane from the line's opening in 1830 until it was superseded by the South Eastern railway's new station in 1846. Whitstable trains henceforth were worked from the new station and the old North Lane terminus relegated to a goods station,

Close to the site of the original Canterbury and Whitstable Railway terminus, the goods yard weighbridge was installed beside the cottage.

becoming part of the goods yard for the SER's Canterbury West. The yard remained until the 1980s when the sidings were taken away and the site redeveloped.

Most of the old company's buildings were eventually demolished, but the stationmaster's house, stables and weighbridge cottage survived. A weighbridge was a common feature of a busy goods depot, and whilst most of the goods yard has been redeveloped for housing, the cottage continues as a private residence. Looking in the direction of Whitstable from North Lane, the weighbridge itself was in the roadway in front of the cottage.

42. Rechabite House, Pound Lane (nineteenth century)

Canterbury may have been the centre of the Church of England for centuries, but this has not stopped those of a different persuasion from finding a home in the city. In Pound Lane, two adjoining semi-detached cottages are named for just such a group: the Rechabites.

The Independent Order of Rechabites was founded as a temperance society in northern England in the 1830s, their name coming from the biblical figure Rechab,

Rechabite House stands adjacent to one of the twenty-four towers added to the city walls in early medieval times.

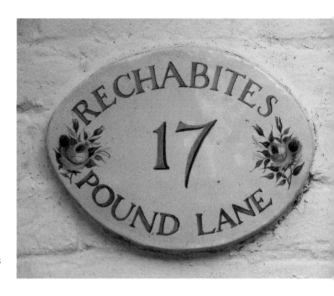

The only visible clue to the property's former use.

whose followers eschewed alcohol. The movement spread across the country with the Canterbury 'tent' or branch taking over a building once used by Primitive Methodists and then Plymouth Brethren, on land owned by the artist Sidney Cooper. It served as the Rechabite Temperance Hall from 1900 to the 1950s with the Christadelphians succeeding them in 1956.

Finally, in 1974 the hall was converted into two houses, which are today named 'Rechabites', although the name only reflects one period of its earlier history. The Rechabite organisation survives today as an ethical financial institution.

43. Barton Mill, Barton Mill Road (sixteenth century onwards)

Many watermills once stood on the banks of the River Stour, powering not only the grinding of grain but also the manufacture of paper and the tanning of hides for the local leather industry. Most have disappeared completely.

Barton Mill was the last surviving of the city's watermills, downstream of the former city wall. At one time a paper mill, and the property of Christ Church Priory, it later became a corn mill. Following the Dissolution in the early 1540s, it passed first to the Crown, and was then acquired by Christopher Hales, attorney general to Henry VIII and member of a prominent local family. A subsequent owner, Allen Grebell, built a substantial adjacent residence.

Two waterwheels once drove the two giant millstones within the mill with a third wheel probably in use for additional machinery. The wheels kept turning until a fire in 1951 led to modernisation of the building, but another blaze in 2004 brought milling to an end. The seven-storey construction has now been converted into private homes.

Surviving axle and supporting columns from Abbot's Mill, destroyed by fire in 1933.

The machinery and waterwheels have gone, but Barton Mill has been adapted for residential use.

It is also still possible to examine the site of Abbot's Mill, in St Radigund's Street, adjacent to the bridge over the Great Stour. The second largest building in the city, it was designed by John Smeaton, who designed the Eddystone Lighthouse. Built in 1792 and costing £8,000, it was over 30 metres tall with an octagonal tower; for 150 years it was the tallest building in the city, second only to the cathedral. It too fell victim to fire, being destroyed in a huge blaze in 1933. Some of the original 1792 metalwork remains in situ.

44. The Synagogue (1847)

In the late eighteenth century, Europe, thanks to Napoleon's campaigns, had become fascinated by the art and architecture of ancient Egypt. A style of architecture developed known as Egyptian Revival and the synagogue on King's Street is amongst its finest examples. Constructed between 1846 and 1847, it stands on the site of a medieval Knights' Templar Hospice, flanked by two Portland cement columns capped with lotus leaf capitals. In the garden behind the

The old Synagogue from the street.

The building is an excellent example of mid-nineteenth-century Egyptian Revival architecture.

A detail of one of the capitals.

main structure is a women's bathing house known as a mikver, whilst inside the building the women's balcony is supported by an obelisk in Egyptian style.

By the early twentieth century the Jewish community in the city was too small to sustain the building and it was closed until King's School acquired it in 1982. It is used mainly for school events, and Jewish students attending the city's universities do hold occasional services there.

The building is not the only synagogue to have existed in the city, however. Cathedral archives tell us that in the twelfth and thirteenth centuries there was a thriving Jewish community of around a hundred, occupying some twenty houses centred around Jews' Street, now Jewry Lane. The houses were close to the Royal Exchange, one of only two centres in the country where silver and plate could be legally traded, with the Mint close by. The community clearly was at the heart of the commercial centre of the city and seems to have had profitable links with Christ Church Priory. The latter apparently turned often to local Jewish financiers when ready cash was required for its ongoing needs. In 1192 Canterbury's Jews were charged with collecting the ransom demanded by Richard I's captors for his release. Worth roughly £2 billion in today's terms, after collection it was stored in a cellar on the corner of Stour Street and Jewry Lane, before being dispatched a quantity at a time.

The relationship between Jews and Christians in Canterbury disintegrated during the thirteenth century amidst a general wave of anti-Semitism, culminating in Edward III's expulsion of all England's Jews in 1290.

In 1654 Cromwell readmitted them and slowly a Jewish community was re-established in Canterbury. A new synagogue was built in St Dunstan's which had to be demolished in 1846 to make way for the level crossing still operating today; a public appeal provided the funds for the building described here.

45. Canterbury Prison and Sessions House, Longport (nineteenth century)

Originally known as St Augustine's Gaol, the prison was designed by the architect George Byfield and built on former abbey land. Replacing an earlier jail at St Dunstan's, it was opened on 14 December 1808, with prisoners being walked in chains from the old prison to the new. Clearly not wishing to spend the festive

The prison entrance bearing the legend 'county gaol and house of correction'.

Above left: Symbols of order and authority. The entrance to Sessions House features crossed fasces with the cap of liberty.

Above right: The railings at the entrance to both the prison and Old Sessions House also feature the axe motif.

season incarcerated behind its 6-metre-high walls, the seventeen-year-old petty thief John Betts managed to escape on the way.

Jane Austen visited with her brother, a magistrate, and must have found it a far cry from her usual haunts. By the 1860s, there were 152 male and fourteen female inmates occupying 132 cells although there was gas lighting and fresh water provided by prisoners operating the treadmill.

It became a government archive store during the First World War and served as a naval detention centre during the Second World War before reverting to use as a normal prison, with the notorious Kray twins at one time being jailed here.

With some 300 inmates it was described by the Prison Reform Trust as the most overcrowded prison in the country in 2003, with concern for the high suicide rate amongst inmates. Four years later it was converted to hold foreign nationals only, with specialist language and immigration services. It closed in 2013 and shortly afterwards the site was purchased by the adjoining Christ Church University for development as a new science and engineering faculty.

The adjacent Sessions House, also dating from 1808, was originally linked to the prison via a tunnel, now blocked. Faced in Portland stone with large Doric columns it was clearly intended to impress. Above the entrance are carved images

of axes and fasces (wooden rods), symbols of authority that are repeated atop the run of original iron railings around the prison.

In 1998 the building became part of Christ Church University and is now known as Old Sessions House, its conversion having won the architect a RIBA award.

46. Kent and Canterbury Hospital, Ethelbert Road (1937)

The city's original County Hospital was built in Longport in 1793, at the site of today's entrance to St Augustine's Abbey. By the 1920s, it was proving too small to cope with Canterbury's increasing population and a site in Ethelbert Road was eventually purchased for the construction of its replacement. The new Kent and Canterbury Hospital opened in 1937, meeting with great public approval of its state-of-the-art facilities and art deco design.

This architectural style was extremely popular in the interwar years, as its bold geometric shapes and sleek lines seemed to epitomise the modern age. The hospital's central clock tower, flat roofs and unfussy lines are typical art deco features.

The 1930s art deco hospital design of Cecil Burns.

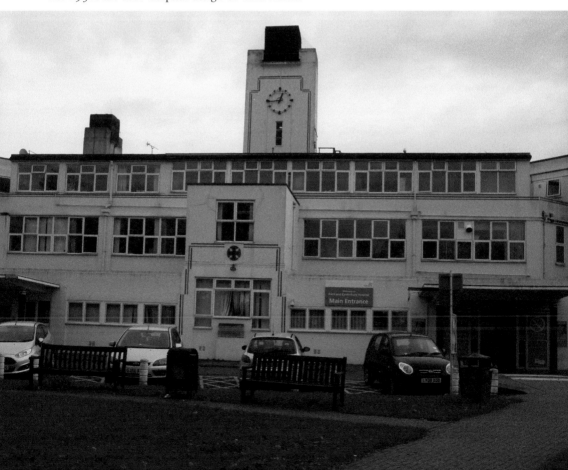

The modernist central clock tower features prominently.

47. University of Kent, Tyler Hill (twentieth century)

A university in Canterbury was first considered in 1947, but it was not until 1962 that work began on Beverley Farm, a rural site to the north of the city. In 1968, Michael Beloff's book *The Plateglass Universities* christened the seven universities built in that decade thus, to describe their architectural use of large amounts of glass, steel and concrete.

Opening in 1965, with only a few buildings and a mere 500 students, the university expanded rapidly in the years that followed and now has some 6,000 students living in its 1.2-kilometre-square campus. Its most recent buildings include the School of Arts (2009), the Colyer-Fergusson Music Building (2012) and a £27 million refurbishment of the Templeman Library in 2017.

The university has also extended beyond the city, with a large campus at Medway, in association with the University of Greenwich, Christ Church Canterbury and Mid-Kent College, as well as a centre in Tonbridge. The university prides itself on its international outlook and has post-graduate centres in Paris, Athens and Rome.

The Senate House of the University of Kent at the 120-hectare city campus.

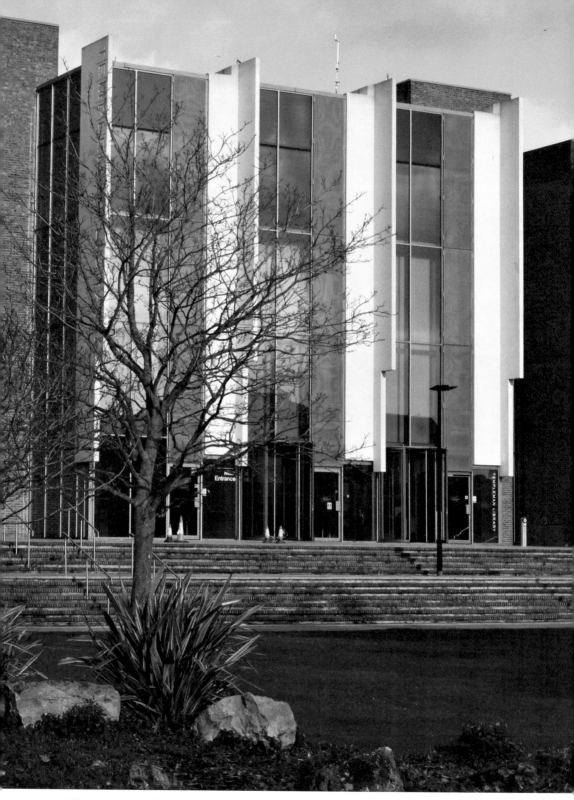

The Templeman library.

The University's Gulbenkian Theatre and adjacent concert hall have become a focal point for the performing arts in the city.

48. Canterbury Christ Church University, North Holmes Road (twentieth century)

Originally founded as a teacher training college by the church of England in 1962 in response to a national shortage of teachers, it began with only seventy students and nine lecturers, with lessons held in the Priory adjacent to St Martin's Church. Having gained a national reputation as a training college for teachers, the establishment gained full university status in 2005, at which time it became known as Canterbury Christ Church University. With around 15,000 students it offers a wide range of undergraduate and postgraduate degrees. The position of Chancellor is held by the Archbishop of Canterbury.

Although the university now occupies several sites in the city, the original campus in North Holmes Road is built on land once occupied by orchards and domestic buildings of the adjacent St Augustine's Abbey. At the heart of this site is the Chapel of Christ in Majesty, to one side of a central courtyard, with many other buildings named after former archbishops.

The chapel at the heart of Christ Church University.

49. Old Tannery, Stour Street (twenty-first century)

Apart from the various corn and paper mills which used the River Stour as a source of power, Canterbury was also home to a sizeable tanning industry. The last to survive was St Mildred's Tannery, which closed in 2002, and the site has since been redeveloped for housing with a mix of new-builds and conversions.

St Mildred's Tannery was established in the late eighteenth century and in 1879 the owners, Farrar & Company, sold the business to the Williamson family, who already operated one or two other tanning yards in the city. Although the smells associated with tanning were not very attractive to nearby residents, the Williamson business, which had been established in the 1790s, continued to thrive and grow, and by the time of closure had employed six generations of the family.

The fine leather supplied by Canterbury was used in the motoring age by car makers such as Rolls-Royce, and even on the benches of the House of Lords.

A tannery building now converted for residential use.

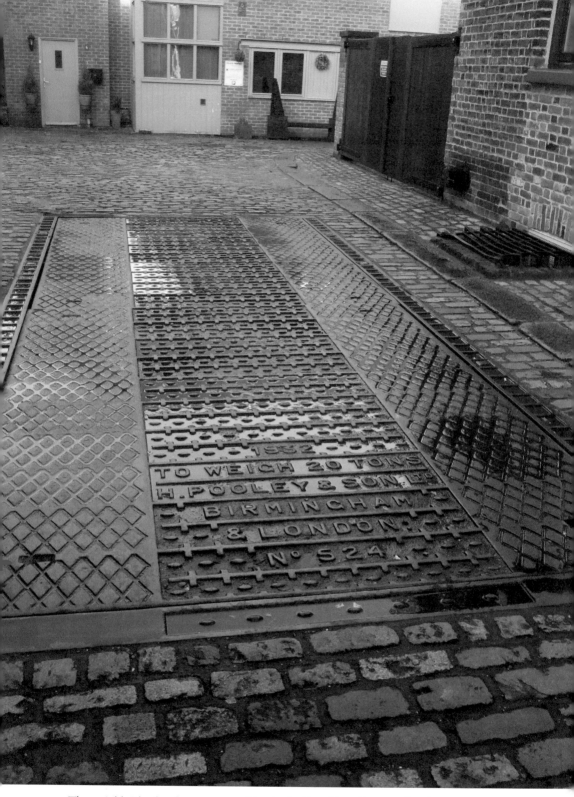

The weighbridge has been preserved in situ in Greyfriars Cottages Road.

50. Marlowe Theatre, The Friars (2011)

Just before the First World War, a small theatre opened in St Margaret's Street, close to the site of the Roman theatre where rather more gory shows had once been the order of the day. In the 1920s the venue became a cinema known as the Central Picture Theatre. It was not successful and soon reverted to its original role as a theatre, used by local amateur dramatics groups.

In 1949 it became known as the Marlowe Theatre, after Christopher Marlowe, who was born in the city and educated at King's. A contemporary of Shakespeare, his own plays include *Dr Faustus* and *Tamburlaine*. This building was demolished during the development of the Marlowe Arcade shops in the 1980s with the second Marlowe Theatre being created by the conversion of the old Odeon Cinema in an area known as The Friars.

The theatre was highly successful but by the early 2000s it was clear that the wish to stage more ambitious productions with better facilities for audiences, including disabled access, meant the converted 1930s building was no longer fit for purpose. In 2009 it was demolished and in 2011 the third Marlowe Theatre was opened; its increased audience capacity and modern technical facilities have lured the RSC, the National Theatre, and Glyndebourne to bring world-class shows to Canterbury – although the annual pantomime probably remains its favourite offering.

Opened in 2011, the new Marlowe Theatre replaced an earlier building on the same site.

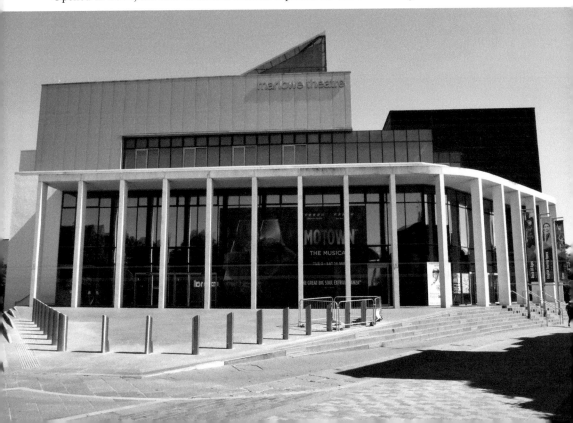

Above left: The *Muse of Poetry*, which stands outside the theatre, was sculpted by Edward Onslow Ford in 1891 in memory of the playwright Christopher Marlowe.

Above right: Nearby a life-size bronze statue commemorates the life of Dave Lee, pantomime Dame at the Marlowe for many years.